CONNECTICUT
Witch Trials

THE FIRST PANIC IN THE NEW WORLD

CYNTHIA WOLFE BOYNTON

THE
History
PRESS

Published by The History Press
Charleston, SC 29403
www.historypress.net

First published 2014

Manufactured in the United States

ISBN 978.1.62619.387.1

Library of Congress Cataloging-in-Publication Data

Boynton, Cynthia Wolfe, author.
Connecticut witch trials : the first panic in the new world / Cynthia Wolfe Boynton.
pages cm
ISBN 978-1-62619-387-1 (paperback)
1. Trials (Witchcraft)--Connecticut--History--17th century. I. Title.
KFC3678.8.W5B69 2014
133.4'309746--dc23
2014032817

To Teddy, who cast the first spell

Every old woman with a wrinkled face, a furr'd brow, a hairy lip, a gobber tooth, a squint eye, a squeaking voice, or a scolding tongue…a dog or cat by her side, is not only suspected but pronounced for a witch.
—seventeenth-century English clergyman John Gaule

Contents

Acknowledgements 9
Introduction: Emerging Out of Salem's Shadow 11

1. Cauldron of Fear: Connecticut Executes First
 Accused Witch in America 17
2. Conjuring Hysteria: Beliefs About Witchcraft in the 1600s 27
3. Dark Spell: The Impact of Mary Johnson's Confession 34
4. Dangerous Brew: The Hartford and Fairfield Witch Panics 41
5. The Devil's Familiars: Some of the More Infamous
 Connecticut Witchcraft Cases 59
6. New Incantation: A Quiet Cry to Stop the Witch Hunts 71
7. Wicked Democracy: Government and Gallows in Connecticut 81
8. The Wallingford Witch: Connecticut's Final Witchcraft Trial 90
9. Bewitched: Myths and Mistruths About Connecticut's
 Witch Trials 97

Afterword: Descendants Petition for Posthumous Pardons 105
Timeline: Connecticut Witch Hysteria 111
Chart: Connecticut Residents Accused of Witchcraft, 1647–1724 115
Bibliography 119
Index 123
About the Author 125

Acknowledgements

A ll those cited as sources within chapters and the bibliography deserve to be acknowledged. So do all those touched by Connecticut's witch trials. Though the Puritans lived in a new world, most followed old beliefs. Too many also allowed fear, and the black side of human nature, to guide their actions.

All those approached for information, interviews and insights during the researching and writing of this book were tremendously generous in how they shared their time, resources and expertise. Special recognition to author R.G. Tomlinson for his meticulous and magnificent *Witchcraft Prosecution: Chasing the Devil in Connecticut*, as well as to Stanley-Whitman House executive director Lisa Johnson, Connecticut state historian Walter Woodward and the gracious staff of the Connecticut State Library's History and Genealogy Department.

Also unending thanks-yous to my parents, Barbara and Ted Wolfe; my husband, Ted; my sons, Teddy and Steven; my inspiring colleagues in the Writing and Oral Tradition cohort at The Graduate Institute; Tabitha Dulla at The History Press for her equally unending patience; and to my purr-fect writing companion, Coal the cat. If I were a witch, you would be my familiar.

Emerging Out of Salem's Shadow

C onnecticut's witch hunt was the first and most ferocious in New England. Yet few know it ever occurred.

Puritans throughout young, colonial America accused at least one hundred people of witchcraft before Salem's infamous, and now internationally known, witch hysteria. Maine, Rhode Island, New Hampshire, Virginia, Maryland, North Carolina and New York all conducted witchcraft trials during the seventeenth century, though Connecticut holds the dark honor of carrying out young America's first witchcraft execution in 1647, forty-five years before Salem hanged Bridget Bishop or crushed Giles Corey.

Connecticut also holds the dubious distinction of having a witch panic that spanned several decades versus Salem's seven months and, ultimately, a witch hunt that was proportionally much more deadly. Salem executed just 20 of the roughly 180 women and men brought up on formal witchcraft charges, while Connecticut executed 11 out of 34.

"In other words, a charge of witchcraft in Connecticut meant that you would very likely die," said Connecticut state historian Walter Woodward at a lecture in Stratford, Connecticut. In that coastal city roughly 360 years earlier, a woman listed in court records as Goody Basset confessed to witchcraft in May 1651 and was hanged, most likely from crude gallows erected near what's now the West Broad Street exit off Interstate 95, in the area of Sterling Park and the Old Congregational Burying Ground.

Although court records are scant, those that exist show that while Goody Basset maintained her innocence throughout her trial, whatever courage she had left disappeared as she walked to the gallows: "Bursting from the procession of…magistrates, ministers and all the dignitaries of the neighborhood, the unfortunate woman threw herself upon a large rock by the roadside," one historian wrote. "She clutched it so desperately that, when at length she was forcibly detached, bloody marks like fingerprints were seen upon it."

Although most of Connecticut's witchcraft cases occurred in Hartford and Fairfield, the colonies of New Haven, Wethersfield, Saybrook, Windsor, Wallingford, Easthampton, Farmington, Setauket and Stamford all had "outbreaks" of women and men believed to be in league with the devil.

After Goody Basset, Stratford became involved in Connecticut's witch trials a second time in November 1692 when a man named Hugh Crotia said the devil told him to hold down and assault a young girl. Judges dismissed the charge, calling Crotia's case not one of witchcraft but of "ignoramus," which in the seventeenth century did not, as it does today, describe a person who is an idiot or a fool. In the 1600s, "ignoramus" was a legal term for "we are ignorant of," meaning judges were not able to determine what exactly happened between Crotia and the girl. So rather than him being bodily punished, he was released with a fine.

Unfortunately, just as judges in 1692 were ignoramus of what happened between Crotia and the young girl, most people today are ignoramus of Connecticut's witch trials.

Part of the reason is a lack of records. There are no known diaries or first-person accounts from those who witnessed the trials. And the majority of court ledgers and other documents from the period no longer exist. The few delicate, handwritten court papers and depositions that do remain are housed in archives at the Connecticut State Library, Connecticut Historical Society and within the Samuel Wyllys Papers at Brown University's John Hay Library. Many of these sheets are torn and yellowed, though the Wyllys Papers—while incomplete—include insightful details about several of Connecticut's accused women, men and couples.

Through the slow, painstaking work of dedicated historians and the ancestors of those accused, details about the lives of some of these "witches" have begun to take shape over the years, as snippets of information found in long-unopened files and town records have been matched with those scrawled onto pages of family Bibles, letters and scrapbooks. But still, Connecticut's witch trials are unknown to most. Although a handful of plays and stories

have been written about the time period, Connecticut has had no Nathaniel Hawthorne, Arthur Miller or other famed storyteller to bring the trials to vivid or widespread life.

In 1958, Massachusetts author Elizabeth George Speare wrote the Newbery Medal–winning *The Witch of Blackbird Pond* inspired by Wethersfield, Connecticut's witchcraft history. But despite being part of language arts curriculums in middle schools around the country, *Blackboard Pond* has never brought to Connecticut the kind of historical recognition that Salem received from Hawthorne's *The House of the Seven Gables*, Miller's *The Crucible* or countless other works.

Connecticut's role in colonial witchcraft history has, in fact, been so well hidden over the centuries that when Yale-educated historian and theologian Benjamin Trumbull wrote *A Complete History of Connecticut* in 1818, he incorrectly stated in its preface: "It may, possibly, be thought a great neglect or matter of partiality, that no account is given of witchcraft in Connecticut. The only reason that is, after the most careful researches, no indictment of any person for that crime, nor any process relative to that affair, can be found."

Of course, we now know this wasn't the case. Through the scant accountings that exist, we know at least fifty Connecticut colonists were suspected of witchcraft, though only thirty-four were formally accused. Historians believe that number may actually be higher. However, knowing what could very likely be their fate, many of those accused fled to Rhode Island, New York and elsewhere before they could be formally charged.

Sadly, details about most of those colonists who stood trial for witchcraft will, in all likelihood, remain as scant and mysterious as information about those who escaped prosecution.

One person hoping to change this is Lisa Johnson, executive director of the Stanley-Whitman House in Farmington, Connecticut. Featuring exhibits and programs designed to educate visitors about the state's earliest days, the museum has become an "unofficial center" for reference materials related to Connecticut's witch trials, Johnson said, as well as the home base for "anything and everything" about Farmington resident Mary Barnes, whose witchcraft execution in January 1663 was Connecticut's last.

Annual commemorations at the Stanley-Whitman House dedicated to Barnes include a month-long witchcraft trials exhibit, the performance of an original play about Barnes and, on milestone years like the 350th anniversary of her death in 2013, a symposium that brings together

colonial New England history and witchcraft experts for panels and other discussions.

With the help of a grant from the Connecticut Humanities Council, Johnson and a team of volunteers have also compiled a survey of all known primary and secondary Connecticut witchcraft trial sources, including their locations. "It was fun. We went from city to city, meeting lots of great people and pulling together a lot of great findings. There's a wealth of information at the local level," Johnson said. "And what we hope will happen is that people will use these materials to erase some of the mythology that's built up around witch trials. It seems that in too many instances, we like the mythological stories more than we like the actual ones, but I happen to think that real life is better than fiction.

"The only way to bust the myths is to get the true stories out there," Johnson continued. "There are a number of people and agencies quietly doing this work, but we're a drop in the bucket compared to what needs to be done. I hope that one day, some kind of widely viewed happening occurs, or item is created, to accurately tell and connect all of the state to Connecticut's witchcraft story."

This book attempts just that.

Nicknamed "Witch City," Salem, Massachusetts, has become synonymous with witchcraft in New England. Yet even if the Salem trials never occurred, colonial New England would still have a stunningly long, fierce and complex history of witchcraft panics, which started in Connecticut. But the Nutmeg State can also be credited with casting skepticism on the evidence that was being allowed to lead to guilty verdicts. Led by levelheaded Governor John Winthrop Jr., who believed people were too quick to attribute unexplainable but "natural misfortunes" to witchcraft, Connecticut evolved from being New England's most aggressive witch hunter and executioner to its most tolerant.

But before we delve into the full story, a note about vocabulary and the mindset of the time: it's imperative to understand that the witch "hunts" that took place in Connecticut and all of the colonies were not actual pursuits of people already identified as witches. Rather, the hunts consisted of efforts to identify colonists who were secretly living as witches. The hunts were searches—generally conducted only after public suspicion was raised—to find individuals in league with the devil who, the Puritans believed, had the power to shape-shift, control the weather, cause accidents and kill. For Puritans, who lived by absolute rules in a world where there was only right and wrong, black and white, witches were people who needed to be destroyed

before they could destroy the livelihoods and lives of others. There could be no other choice.

Ruthless. Cruel. Fascinating. Forgotten. Connecticut's overlooked and largely unknown witch trials are long overdue to be brought into the forefront. It's a riveting period in American history, and there are important lessons to be learned from better understanding it—important reminders of where fear, greed and ignorance can lead us. Learning about Connecticut's witch trials gives us the opportunity to consider not just who we once were but also who we want to be.

Cauldron of Fear

Connecticut Executes First Accused Witch in America

It has…been made a doubt by some, whether there are any such things as Witches, i.e., such as by contract or explicit Covent with the Devil…Though it be Folly to impute every dubious accident to Witchcraft…some things cannot be exempted against.
—*Puritan minister Cotton Mather in his book* Memorable Providences, *1689*

In the 1600s, Satan and his supernatural forces were seen as very real threats to those living in wild New England. Austere in manner, attitude and appearance, Connecticut's first colonists, like all Puritans, believed the devil literally walked the earth, causing cows' milk to dry up, corn crops to fail, carefully made cheese to turn sour and desperately needed rain to not fall. Claiming *maleficium*—the Latin term for "mischief" or "wrongdoing," used to describe evil or malevolent sorcery—Puritans blamed Satan for sudden sicknesses, tragic accidents and too-early snowfall. These early American settlers lived in what author and women's studies expert Elizabeth Reis called a "world of wonders, where earthquakes, comets, floods, thunderstorms and everything [unexplainable was] the mysterious workings of either God or the devil." They believed that on a daily basis, the devil and his minions tested humans' faith and will, looking for new recruits to join their evil army.

Ministers preached that only strong-minded men and women who strictly followed God's teachings and were committed to living simple, pious lives could resist the devil's often-appealing temptations. Those with weak resolve, lack of faith or more interest in having a pleasurable life than a pleasurable

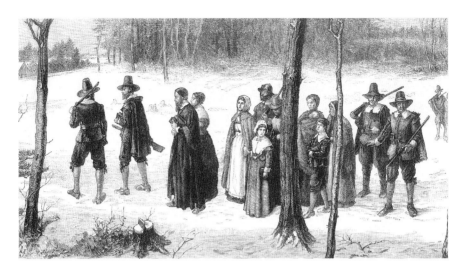

Daily life for early New England Puritans was often difficult and fearful, as illustrated in this 1867 oil painting by English American painter George Henry Boughton. *The Early Puritans of New England Going to Church* is part of the Robert L. Stuart Collection at the New York Historical Society, on permanent loan from the New York Public Library.

afterlife were at risk of diabolical influence and falling. Women's nature made them particularly vulnerable, Puritans believed, as proved in the first chapter of the Bible and how easily the devil, in the guise of a serpent, pulled Eve away from God by convincing her to eat the forbidden fruit in the Garden of Eden.

Women and men who, like Eve, became lost to God to serve the devil as witches and masters of the supernatural world needed to be stopped, ministers said, before they had the chance to harm or influence others.

A HISTORY OF FEAR

For centuries, witchcraft was a feared practice known to exist in cultures and countries throughout the world. At the time the Puritans left England for the New World, witch hunts believed necessary to protect the good and faithful were as much a part of community life as beliefs that witches rode through the night on brooms. Similar to how New England Puritans believed they needed to leave England to "purify" the Anglican church of crucifixes, incense and other signs of Catholicism, Christians throughout Europe

believed they needed to purify their villages by ridding them of witches who held secret sabbats, had orgies with the devil and used the fat of murdered children to cast spells.

If Puritans settling the Connecticut Colony in 1636 believed the threat of witchcraft did not exist in this new land, they learned they were wrong fairly quickly. Just eleven years after Puritan minister Thomas Hooker and Massachusetts Bay Colony governor John Winthrop Sr. brought one hundred men to present-day Hartford to found Connecticut, the colony executed both Connecticut's and young America's first convicted witch, Alse (Alice) Youngs of Windsor.

No records of Alse's life, indictment, trial or execution are known to exist. In fact, her dark distinction as the first person in New England and the New World to be convicted and hanged for witchcraft might have been lost altogether if not for a vague—but essential—single line in Winthrop's journal from the spring of 1647. It read: "One —— of winsor arrayned & executed at Hartford for a witche." The name of the person executed remained a mystery until 1904, when historians found an entry in the diary of colonial Windsor's second town clerk, Matthew Grant, which stated that: "May 26, 47 Alse Younges was Hanged."

Assumptions based on these slim records and other facts known about the time period include that Grant incorrectly added an "e" to Alse's last name. It's also believed that she was either the wife or daughter of a man named John Youngs, who purchased land in Windsor in 1641 and sold it two years after Alse's death to move to Stratford.

Since in seventeenth-century Connecticut the village of Hartford was home to the colony's Particular Court, which met every three months and tried all serious crimes, Alse's trial and execution almost assuredly took place there. Many believe the gallows used to hang her were erected in Meeting House Square, the location of today's Old State House on Main Street, though the majority of later hangings most likely occurred in the Hartford Colony's south pasture, in the vicinity of today's Dutch Point, near where Irving Street meets Albany Avenue. "The spectacle was very important in colonial days, so it had to be in a spot where everyone would see the hanging," said Trinity College librarian Richard Ross, who has taught courses at the Hartford university about Connecticut's witch trials.

Because Connecticut had no capital laws in place until December 1642, it's unlikely that anyone was executed for witchcraft prior to Alse, although lack of records from the period allows the possibility to exist. Countless questions about Connecticut's witch trials also exist, including exactly what

[92] CAPITALL LAWES ESTABLISHED BY THE GENERALL COURT, THE FIRST OF DECEMBER, 1642,

1. Yf any man after legall conuiction shall haue or worship any other God but the Lord God, he shall be put to death. Deu : 13. 6, & 17. 2 : Ex : 22. 20.

2. Yf any man or woman be a witch (that is) hath or consulteth w^th a familliar spirit, they shall be put to death. Ex : 22. 18 : Lev : 20. 27 : Deu : 18. 10, 11.

3. Yf any p^rson shall blaspheme the name of God the Father, Son or Holy Goste, w^th direct, expres, p^rsumptuous, or highhanded blasphemy, or shall curse God in the like manner, he shall be put to death. Leu : 24. 15, 16.

4. Yf any p^rson shall comitt any willfull murther, w^ch is manslaughter comitted vppon mallice, hatred or cruelty, not in a mans necessary and iust defence, nor by mere casualty against his will, he shall be put to death. Ex : 21. 12, 13, 14 : Num : 35. 30, 31.

5. Yf any person shall slay another through guile, ether by poysonings or other such divillishe practice, he shall be put to death. Ex : 21. 14.

6. Yf any man or woman shall ly w^th any beast or bruit creature, by carnall copulation, they shall surely be put to death, and the beast shall be slayne and buried. Leu : 20. 15, 16.

7. Yf any man lye w^th mankynd as he lyeth w^th a woman both of them haue comitted abomination, they both shall surely be put to death. Leu : 20. 13.

A copy of the Connecticut Colony's "Capitall Lawes," published in 1850 by Hartford's Brown & Parsons, listed in order of severity. Witchcraft is number two.

Alse Youngs did to bring about witchcraft suspicions. Unfortunately, until a lost diary or forgotten records are unearthed, there is no way to know for sure. "One of the problems of that time period is that there wasn't a lot of consistent and systematic record-keeping," added Ross. "There are no known writings about the hangings, and we don't have any first-person accounts. For some of the cases, there are detailed accounts of the indictments and convictions. But over time, many papers from seventeenth-century events like the witch trials have disappeared."

What is known, however, is that, like it was in England, witchcraft in Connecticut and all the New England colonies was a capital offense punishable by death if convicted by a court of magistrates. All twelve of the "Capitall Lawes" created by the Connecticut Colony's "Generall Court" were based on literal interpretations of the Bible, with the number one offense being to "worship any other God but the Lord God." Often referred to as "Mosaic" crimes because of their similarity to the ten commandments Moses brought down from Mount Sinai in the Old Testament, the number two offense was that "any man or woman be a Witch" or to "hath or consulteth w'th a familliar spirit."

Sprung from medieval European folklore, familiar spirits—more commonly referred to as "familiars"—were believed to be demons that appeared in the form of cats, rats, snakes, birds and other common animals to carry out a witch's work and help pass messages to and from Satan, ghosts and other diabolical creatures. Puritan lawyer and minister Nathaniel Ward wrote about the threat of familiars in the witchcraft law he crafted for the Massachusetts Bay Colony, which the Connecticut Colony adapted. Based on a 1618 English judicial treatise called *The Country Justice*, the law said:

> *These Witches have ordinarily a Familiar or Spirit, which appeareth to them sometimes in one shape, sometimes in another; as in the shape of a Man, Woman, Boy, Dog, Cat, Foal, Hare, Rat, Toad &c. And to these Spirits they give names, and they meet together... Their said Familiar hath some big or little Teat upon their body, and in some secret place, where he sucketh them. And besides their sucking, the Devil leaveth other marks upon their body, sometimes like a blue spot or a red spot, like a flea biting, sometimes the flesh sunk in and hollow (all which for a time may be covered, yea taken away, but will come again to their old form). And these Devils' marks be insensible, and being pricked will not bleed, and be often in their secretest parts, and therefore require diligent and careful search.*

Physically examining accused witches for a "witches teat," or other body mark from which it was believed the devil or his minions could feed, was a routine part of Connecticut witchcraft's investigations. Thankfully, *The County Justice*'s recommendation that those who practice "Witchcraft, Enchantment, Charm or Sorcery" be burned on a stake was not enacted in Connecticut or anywhere in New England. There is, in fact, no sign that any Connecticut person charged with witchcraft was tortured with red-hot

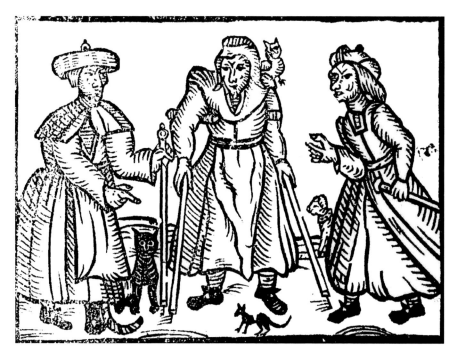

A seventeenth-century woodcut, author unknown, of three witches with their familiars—spirits that were believed to take the form of cats, owls, dogs and other animals to help witches cast spells or convey information from the devil.

irons, scalding water, iron collars, kneecap vices or any of the other heinous methods used during the European witch hunts that so greatly influenced New England Puritans' mindset.

"Searching," "waiting" and applying a mix of sleep deprivation, isolation and intense psychological pressure were the primary means of interrogation in Connecticut, though in a handful of cases, the infamous water test was used to prove whether "ye witch [had] made a pact with ye devil…[and] renounced her baptism." For the water test, before being dropped into a lake or river, the accused was cross-bound with rope, the right thumb tied to the left big toe, and the left thumb tied to the right big toe. If the suspect sank, she was proclaimed innocent. If she floated, she was proclaimed guilty, her evil spirit rejected by what ministers said was pure water. Another theory was that each time the devil or one of his minions sucked a witch's teats, he infused her with a venom that made her buoyant.

"The seventeenth-century era of the witchcraft prosecutions was a much different time than our own," said Lisa Johnson, executive director of the

Stanley-Whitman House museum in Farmington, which has dedicated a section of its library to Connecticut's witch trials. Explained Johnson:

> *Even educated people believed that witches were to blame for natural disasters and personal tragedies. But the critical factor that pushed early Connecticut colonists into community-wide witchcraft panics was fear. Consider where and how they lived. Connecticut was a strange new land, far from home, and they were surrounded by unfamiliar people, in an unfamiliar climate that at times felt more than just a little unwelcome. They also practiced a religion that offered no comfort, based on the belief that they had to prove their worthiness of God's love. Life was difficult, and to quote Puritan theologian Cotton Mather, it was a society "wherein the least known evils are not to be tolerated."*

Indeed, fear was an inexorable part of early New England life. Living on small farms that required their owners to work from dawn to dusk, colonists were at constant risk of losing goats to wolves and crops to floods along the Connecticut River. In 1647 and 1648, influenza and smallpox epidemics led to the deaths of dozens of settlers. And the capture and killing of nine Wethersfield colonists by Pequot Indians in 1637 made the threat of a Native American–led "massacre" as much a constant threat as Satan himself.

Food was scarce, each season in this new world brought about a new challenge, and the Puritans had few pleasures to amuse or distract them. There was also religious dissent among members of several Connecticut colonies, leading to cries for ministers' ousters and some settlers to pick up and move to Rhode Island, Massachusetts, New Amsterdam (New York) and other colonies. Those who stayed sat through long, terrifying sermons that each Sabbath reminded them how wickedness and suffering were manifestations of God's "Holy Anger." Since everyone was predestined to salvation or damnation, begging for mercy or forgiveness was senseless. And no one could predict who might be, or become, a witch. Out in the woods, Indians' practices of what Puritans saw as maleficium or sorcery only exacerbated fears.

"We keep only a tenuous link today with a past when personal and collective misfortunes were apt to be explained by the malign presence of devils and spirits," said Carol Seager Fuller, descendant of accused Connecticut witch Elizabeth Seager, in her self-published booklet *An Incident at Hartford: Being an Account of the Witchcraft Trials of Elizabeth Seager and Others.* "To read the records of the [Connecticut] trials 300 years later is to recognize that, in the 17th century, every day was Halloween."

In an "Early History" included in a 1906 book published to mark the 100th anniversary of the founding of Meriden, Connecticut, author George Munson Curits muses on what "to us would be intolerable" aspects of Puritan life, particularly how when it came to criminal charges being lodged, emotion and imagination could overrule fact. "Everyone felt at liberty to spy upon the acts of his neighbor, and that this was thoroughly done no one will doubt who has made an examination of early church records," Curits said. "What to-day is considered the act of a scandalmonger and busybody was then felt to be part of conscientious man's duty. It can easily be imagined that life in such a community was not pleasant."

Guidelines for whether a person living in seventeenth-century Connecticut might be practicing witchcraft were based on those created in Europe four hundred years earlier and included those excerpted here. For those interested in reading the entire document, one of the best sources is John M. Taylor's *The Witchcraft Delusion in Colonial Connecticut (1647–1697)*, which can be downloaded for free from several Internet sources that provide access to copyright-free documents in the public domain. According to this treatise, justifiable reasons for suspicion of witchcraft include the following:

> *Grounds for the Examination of a Witch*
> *1. Notorious defamation by a Common report of the people is a ground for suspicion.*
> *2. A further ground for strict examination is if a fellow-witch give testimony in his examination or death that such a person is a witch. But this is not sufficient for conviction or condemnation.*
> *3. If after cursing there follows death or at least mischief to ye party.*
> *4. If after quarrelling or threatening a present mischief doth follow for parties devilishly deposed after cursing do use threatenings and that also is a great presumption against them.*
> *5. If ye party suspected be ye son or daughter, the servant or familiar friend, near neighbors or old companions of a known or convicted witch, this also is a presumption for witchcraft …*
> *6. If ye party suspected have Devils marks…* [and] *no evident reason can be given for such mark.*
> *7. Lastly, if ye party examined be unconstant and contrary to himself in his answers.*

Simply translated, if you were a seventeenth-century Connecticut Puritan, a formal witchcraft investigation could be launched against you if:

Many of the laws in the New England colonies were based on literal interpretations of the King James Bible, including the passage "Thou shalt not suffer a witch to live" from Leviticus 20:27.

- At least two neighbors said they suspected you of being a witch.
- Someone already convicted of witchcraft testified that you were a witch, too.
- After you threatened or argued with another person, that person suddenly got sick, or their cow died, or a candle led to their house burning down, or another unexpected event occurred for no apparent reason. "Anything unexplainable was blamed on witchcraft," said Connecticut state historian Walter Woodward.
- A close family member or friend is suspected of being a witch.
- You were born with an extra nipple or have an unusual birthmark that could be mistaken for a witch's teat.
- While being questioned, you get angry or contradict anything you previously said.

Women were also particularly at risk. In colonial New England, as it was in Europe for centuries before, most accused witches were women. They were also generally middle-aged, had a relatively low social position and were known for being outspoken, stubborn, contentious or frequently "out of line." Married women accused of witchcraft often had relationships "marred by trouble and conflict" and, frequently, were accused by their husbands, said author John Demos in his book *Entertaining Satan: Witchcraft and the Culture of Early New England*. Most Puritans also held the longtime European belief that women possessed dangerous occult and sexual powers. Widows—especially those who had inherited large estates from their husbands—were most vulnerable.

Women who spoke out against the trials also immediately came under scrutiny. Said Woodward:

> Connecticut was New England's fiercest witchcraft prosecutor. The Puritans' actions seem irrational to us now. But to them, they were being absolutely smart and rational. New England was a new, dangerous place, and life was tenuous. There were no police, hospitals or social services. There was a government in place, but no real safety net. People put their faith in God and relied on each other. To them, religion, science and magic were all intertwined. Satan was as real as God, and everyone believed in the power of both.

Thus, to the Puritans, when God said in Exodus 22:18 "thou shalt not suffer a witch to live," his words were final.

CHAPTER 2
Conjuring Hysteria

Beliefs About Witchcraft in the 1600s

A witch, a witch…Goody Garlick is a double tongued woman. Because I spoke two or three words against her, now she is come to torment me. Did you not see her last night stand by the bedside, ready to pull me in pieces? She pricked me with pins. She pricked me with pins. She pricked me with pins.
—*from the* Records of the Town of East Hampton, *1658*

Perhaps one of the saddest aspects of the witch panics that occurred in Connecticut, and elsewhere, is how they divided communities. Neighbors testified against neighbors. Children testified against parents. Husbands testified against wives and vice versa. This is well-illustrated in the case of Connecticut's Elizabeth Garlick, who in 1658 was accused by her sixteen-year-old neighbor Betty Howell of being a "double tongued woman," torturing her with pin pricks and sending a "black thing" to stand in the corner of Betty's bedroom. When Betty died the next day, her family and neighbors blamed Goody Garlick.

Fifty-year-old Garlick must not have been popular in East Hampton, which today is part of Long Island, New York, but then was a part of the Connecticut Colony. Thirteen villagers testified at Goody Garlick's indictment hearing, telling stories about her involvement with black cats, "threatening speeches," a fat sow and piglets that died, an ox with a broken leg, a man who turned up dead and a child "taken away in a strange manner." Neighbor Richard Stratton told judges he had heard another neighbor, Goody Davis, "say that [Goody Garlick's own] child died strangely…and she thought it was

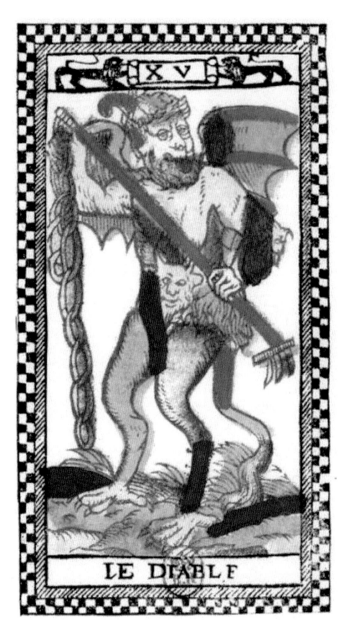

Colonists believed that Satan could affect not just people's actions but also their health, crops and farm animals. This made his supernatural powers a very real threat. Though it was believed the devil could take many forms, a common image is depicted on this tarot card from the "Tarot de Marseille" deck, created in Italy in the fifteenth century.

bewitched, and she did not know of anyone…that could do it unless it were Goody Garlick herself."

Convinced that this "naughtie woman" should stand trial for witchcraft before capital offense magistrates in Hartford, East Hampton judges sent her to the Connecticut Generall Court with a harsh indictment:

> [Goody Garlick], *that not having the fear of God before thine eyes, thou hast entertained familiarity with Satan, the great enemy of God and mankind, and by his help since the year 1650 have done works above the course of nature to the loss of lives of several persons (with several other sorceries) and in particular the wife of Arthur Howell…for which both according to the laws of God and the established law of this commonwealth thou deserveth to die.*

For unknown reasons—no known records exist—Hartford jurors disagreed and found Goody Garlick not guilty. Yet among the many stories that make up Connecticut's witch trials, hers is a too-familiar one: an older woman unjustly accused of maleficium as a way to explain, or blame someone for, suspicious, tragic or baffling events. Indeed, going as far back as the sixth century—the start of the Middle Ages—almost all of the witches persecuted and expelled from European cities for their "unclean spirits" and "foulness" were women.

For most of history, the stereotypical witch was an ugly and old woman; a hag-like crone with warts, snaggle teeth, a pointed nose and sunken cheeks. It's an image that no doubt was brought to New England by the roughly twenty thousand Puritans who left England during the "Great Migration" of the early 1600s for greater religious freedom away from leaders of both the Anglican and Catholic churches. Many of these settlers came from eastern England's Essex region, where for centuries, witches were especially feared and fiercely hunted. Like their diabolical master, witches were hideous creatures, these Puritans believed, inside and out. They were women and men who "signed the devil's book," giving the devil permission to take their shape and use them to inflict disease, spoil crops, summon drought and perform any other imaginable and detestable acts.

The purpose of witches was to destroy everything Christians held sacred: their souls, families, communities, churches and lives. Out of this centuries-old certainty came witch hunts that peaked and waned over a period of several hundred years throughout Europe, including Germany, France, Italy, Switzerland, Spain, Portugal and England. Pope Gregory XI and Pope Innocent VIII in the fourteenth and fifteenth centuries were particularly zealous witch hunters, declaring all magic done with the help of demons to be heresy—punishable by burning—and condemning witchcraft as Satanism.

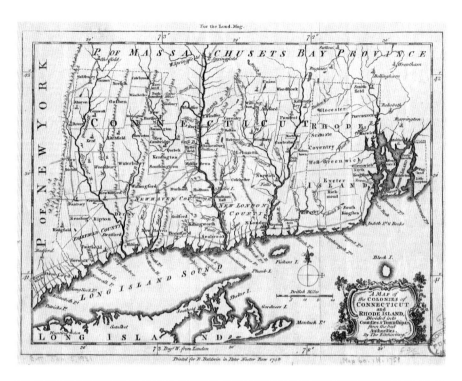

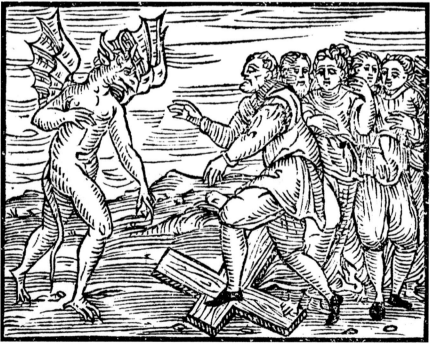

The fifteenth century also saw the publication of a book in Germany called the *Malleus Maleficarum*. Translated into English, *The Hammer of the Witches* provided ministers and magistrates with suggestions on how to best find and convict witches, most of whom, it claimed, were women more susceptible to demonic temptation because of the "weakness of the gender." Women, the *Malleus Maleficarum* said, were more carnal and weaker than men. Especially susceptible, asserted *Malleus* author Heinrich Kramer, were women who tended to overstep the lines of proper female decorum.

The book also accused both male and female witches of infanticide and cannibalism, among other evils, as well as gave women witches the power to steal men's penises. Through magical attack, the book said, witches could make men's genitals disappear. They could make them "hidden by the devil…so that they can be neither seen nor felt," often storing the removed parts in a bird's nest or boxes, where "they move themselves like living members and eat oats and corn."

Widely read and deemed by historians to be one of the most influential books of its time, the *Malleus Maleficarum* played a huge role in shaping New England Puritans' beliefs about the power and heinousness of witches.

If there were any doubters about the dangers of witches among those who settled Connecticut in 1636, it's safe to say English witch hunter Matthew Hopkins most likely changed their minds. Letters from family and friends in England told stories of Hopkins, a young man in his twenties who had developed what seemed to be a foolproof strategy for getting accused witches to confess. He outlined his methods in *The Discovery of Witches*. Published in 1647, the same year Connecticut hanged its first convicted witch, Alse Youngs, the book describes the benefits of "searching" and "waiting," which requires the accused to sit in one specific position, usually with legs crossed, for twenty-four hours. If the accused was a witch, an imp or devil's familiar would appear to feed off the witch's teat.

Opposite, top: Three Connecticut colonists accused of witchcraft—Elizabeth Garlick and husband and wife Mary and Ralph Hall—were from East Hampton and Setauket. These towns are now part of Long Island, New York. But in the 1600s, they were part of the Connecticut Colony. This early map by Thomas Kitchin and Richard Thomas was published roughly sixty years after Connecticut's last witch trial occurred.

Opposite, bottom: An image from German Catholic clergyman Heinrick Kramer's fifteenth-century *Malleus Maleficarum*, which in English means "The Hammer of Witches." The book is designed to discredit those who believe witchcraft doesn't exist and details how to identify, trap and prosecute witches.

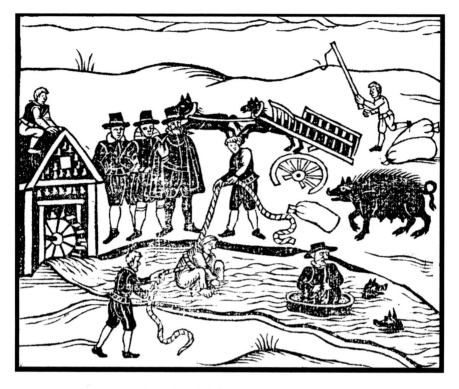

An engraving from the 1613 pamphlet *Witches Apprehended, Examined and Executed, for Notable Villainies by Them Committed Both by Land and Water.* The image shows the water test—one of the trials used to prove whether an accused was a witch. A person who sank was considered innocent; a person who floated was guilty.

Other techniques Hopkins used and recommended included sleep deprivation and cutting the arm of the accused with a blunt knife. If no blood appeared, she was a witch. He also used a version of the water test that required the accused be tied to a chair and thrown into water. Those who floated and were rejected by the "pureness" of the water were deemed witches. Those who sank were innocent but often drowned. When an accused did not appear to have any kind of "devil's mark"—a mole, birthmark, extra nipple or other body mark that all witches were believe to possess—Hopkins shaved off all her body hair and pricked the skin with knives and needles to see whether invisible ones would appear.

The result of these methods was more people being hanged in England for witchcraft over a three-year period than in all the previous one hundred years combined. Between 1644 and 1647, more than three hundred women in England were executed by this self-titled Witch-Finder General.

Letters describing these deaths made their way to Connecticut and elsewhere in the colonies. So did copies of *The Discovery of Witches*. Journal entries written in May 1648 by Massachusetts Bay Colony governor and Connecticut founder John Winthrop Sr. explain how Massachusetts magistrates followed Hopkins's "searching" and "waiting" technique to gather evidence on a woman named Margaret Jones and, within that twenty-four-hour period, saw an imp appear "in the clear light of day." The following month, Jones, a midwife, became the first woman in Massachusetts to be executed for witchcraft.

Although there's no proof Hopkins's book played a role in Alse Youngs's hanging, the timing of its publication and Winthrop's connection to the Massachusetts Bay and Connecticut Colonies' judiciaries can't be overlooked. New England ministers also played their part in stirring up certainty that any threat of witches must be extinguished. Each week from the pulpit of churches in Connecticut and throughout the New England colonies, clergymen warned that even the most righteous were at risk of falling to the devil's temptations and that those who fell were doomed.

Elizabeth Reis, author of *Damned Women: Sinners and Witches in Puritan New England*, wrote about these sermons for the *Organization of American Historians' Magazine of History*. It's important to consider their effects:

> *Ministers make it perfectly clear that intimacy with Satan ended one's chance of attaining saving grace and damned one to an eternity in hell. They preached that unreformed sinners—those who served the devil rather than God—would be doomed, and they peppered their sermons with images of hell's dark abyss...In weekly sermons and written tracts, ministers repeatedly admonished their congregations not to fall prey to Satan's methods. While the devil could not force one to lead a life of sin and degradation, he possessed a frightening array of persuasive tools and temptations and would go to any length to lead people into sin, thereby possessing their souls. Perhaps unwittingly, the clergy's evocative language and constant warnings about the devil's intrusions reinforced folk beliefs about Satan, in the minds of both ordinary church-goers and the clergy. The violent battle between Satan and God described in glorious detail in the ministers' sermons became, during the witchcraft crises, a vicious confrontation between the accused and her alleged victim.*

Dark Spell

The Impact of Mary Johnson's Confession

She said, her first familiarity with the Devil came through discontent…whereupon a devil appear'd unto her, tendering her what services might best content her. A devil accordingly did her many services. Her master blam'd her for not carrying out the ashes, and a devil afterwards would clear the hearth of ashes for her. Her master sending her to drive out the hogs, that sometimes broke into their field, a devil would scowre the hogs away, and make her laugh to see how he feaz'ed them. She confess'd that she had murdered a child, and committed uncleanness both with men and with devils.
—Cotton Mather on the confession of accused witch Mary Johnson of Wethersfield in his book Magnalia Christi Americana (The Glorious Works of Christ in America), *1702*

It was the Reverend Cotton Mather who urged judges in the Salem witch trials to accept spectral evidence—claims that invisible spirits of the accused witches visited and tormented the afflicted girls—as proof of a witchcraft charge. It was also Mather who ensured that the story of the first Connecticut person to confess to being a witch did not become invisible to history.

Only a single sentence about the witchcraft case of Mary Johnson of Wethersfield exists in Connecticut records. Dated December 7, 1648, the court document states: "The jury finds the Bill of Indictment against Mary Johnson that by her owne confession shee is guilty of familiarity with the Devill."

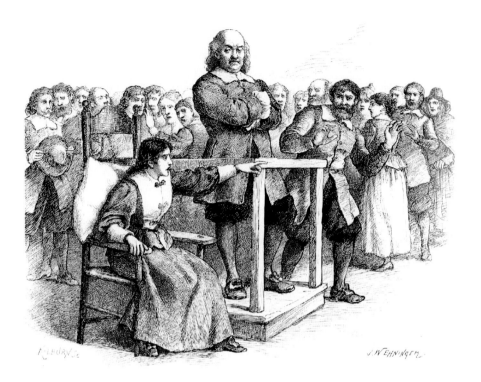

There is no known art depicting Connecticut's witch proceedings, but there are several pieces depicting Salem's, including this one of accused witch Mary Walcott by John W. Ehninger, which appeared in *The Complete Poetical Works of Henry Wadsworth Longfellow* to accompany Longfellow's play *Giles Corey of the Salem Farms*.

Earlier that same day, judges dismissed the case of another Wethersfield woman accused of witchcraft. There was not enough evidence to convict and hang Katherine Palmer, though her reputation for "unruly" behavior earned her a warning and a fine.

For Mary, however, there could be no outcome but death.

A house servant who two years earlier had twice been arrested for stealing and publically whipped both times, Mary was visited in prison by Hartford's senior minister the Reverend Samuel Stone, one of Hartford's founders. Eager to be part of efforts to stop "those who have in the most horrid manner given themselves away to the Destroyer of their souls," Stone urged Mary to confess, which she did, though it should be noted exactly how that confession was obtained is unknown.

At some point during the fifteen years that followed, Stone shared the story of the confession he elicited from Mary with the Reverend William

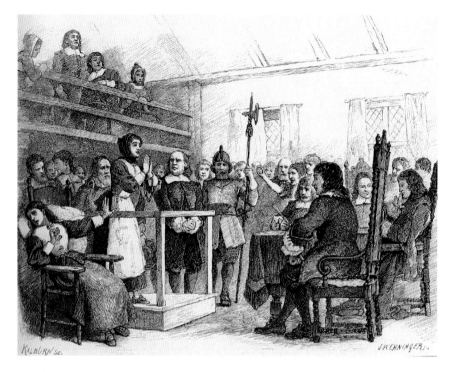

Also from *The Complete Poetical Works of Henry Wadsworth Longfellow*, an image of Martha Corey. Husband and wife Giles and Martha were both accused and killed in Salem.

Whiting. Whiting came to Hartford in 1660 and worked with Stone for three years before succeeding him as senior minister of the church that is today the First Church of Christ, also known as Center Church, at the corner of Main and Gold Streets. Although Whiting had no firsthand knowledge of Mary's case, he told Mather what Stone had said.

Feeling Mary illustrated his belief that even "the worst of Sinners" should not "despair" or "delay" repenting, Mather included her story in his 1689 book *Memorable Providences, Relating to Witchcrafts and Possessions*—a collection, he said, of "many Wonderful and Surprising Things that have befallen several Bewitched and Possessed Persons in New-England." An editor's note at the beginning also points out that "the Ministers of Boston and Charleston" consider it recommended reading.

Starting with an introduction that celebrates God's willingness to "recover" those have fallen to the "Hell of Witchcraft," Mather dedicated two pages to an account of Mary's case:

Sect. I. There was one Mary Johnson tried at Hartford, in this Countrey, upon an Indictment of Familiarity with the Devil. She was found Guilty of the same, cheefly upon her own Confession, and condemned.

Sect. II. Many years are past since her Execution; and the Records of the Court are but short; yet there are several Memorables that are found credibly Related and Attested concerning her.

Sect. III. She said, That a Devil was wont to do her many services. Her Master once blam'd her for not carrying out the Ashes, and a Devil did clear the Hearth for her afterwards. Her Master sending her into the Field, to drive out the Hogs that us'd to break into it, a Devil would scowre them out, and make her laugh to see how he feaz'd them about.

Sect. IV. Her first Familiarity with the Devil came by Discontent; and Wishing the Devil to take That and t'other Thing; and The devil to do This and That; Whereupon a Devil appeared to her, tendring her the best service he could do for her.

Sect. V. She confessed that she was guilty of the Murder of a Child, and that she had been guilty of Uncleanness with Men and Devils.

Sect. VI. In the time of her Imprisonment, the famous Mr. Samuel Stone was at great pains to promote her Conversion unto God, and represent unto her both her Misery and Remedy; the Success of Which, was very desirable, and considerable.

Sect. VII. She was by most Observers judged very Penitent, both before and at her Execution; and she went out of the World with many Hopes of Mercy through the Merit of Jesus Christ. Being asked, what she built her hopes upon; She answered, on those Words, "Come to me all ye that labour and are heavy laden, and I will give you Rest"; and those, "There is a Fountain open for Sin and for Uncleanness." And she died in a Frame extremely to the Satisfaction of them that were Spectators of it.

Our God is a great Forgiver.

Looking back, it's interesting to consider how Mary Johnson—whose beliefs and opinions would normally have little to no impact on any political or judicial decision being made because she was a woman—was in this instance unquestionably taken at her word. Though Puritans considered themselves enlightened about women's place in society and were not misogynists, women in colonial Connecticut did not have a revered or highly respected place in society. Although women could be members of their churches, there was no place in Puritan New England for a woman who wanted to take part in leading her community.

For a Puritan woman, freedom meant embracing her role as wife and mother, as well as subjecting "to her husband's authority." Women's lives focused on the "gentle arts," many of which required work that was anything but gentle—cooking over an open hearth, spinning wool, sewing, raising kitchen gardens, rendering fat, raising and butchering chickens, attending the ill and rearing children. The average Puritan woman spent at least twenty years either pregnant or nursing. Yet despite their daily workload, they were "the weaker vessel," said the King James Bible. For the Puritans, who took each word in the Bible literally, this meant women were weaker in body, mind and soul.

However, according to women's history scholar Elizabeth Reis, it generally wasn't actual guilt that caused women like Mary Johnson to admit to witchcraft. "Confessors' language suggests that the choice to confess or to deny charges of witchcraft paralleled the ways in which women and men confessed more generally in New England," she said in an article about the Salem witch trials for *Organization of American Historians Magazine of History*. This statement, at least in part, seems appropriate to apply to Mary's case: "Women and men thought about sin and guilt differently, whether they were applying for church membership or trying to convince the court that they were innocent of witchcraft. Women were more likely to interpret their own sin, no matter how ordinary, as a tactic covenant with Satan, a spiritual renunciation of God."

In regard to sin and how they viewed themselves, Puritan women tended to take a more broad approach, admitting in church confessions to their overall "vile nature," while Puritan men focused on specific sinful actions, such as gambling or drinking. In other words, Reis continued, "women were more convinced that their sinful natures had bonded with the devil, [while] men seemed confident of their ability to throw off their evil ways and turn to God in time. If women more generally feared they had unwittingly covenanted with the devil, it took less to convince them that they had in fact accepted a literal invitation from Satan to become witches."

What we know of the content of Mary's confession makes it quite possible to believe she felt exactly this way. According to Reverend Whiting, Mary confessed to Reverend Stone of her "uncleanness" with men. Based on this, it's not unreasonable to assume that the "murder" she talks about was the termination of a pregnancy. The fact that she asked the devil to help her with her chores, and earlier had been convicted of stealing, also means that her guilt could have been compounded by her realization that she committed several of the seven sins "that are an abomination" to the Lord, including:

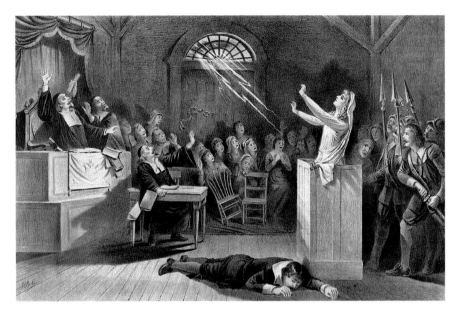

Lithograph *The Witch No. 1* by J.E. Baker, published by George H. Walker & Company of Boston and New York in 1892. *Library of Congress Prints and Photographs Division.*

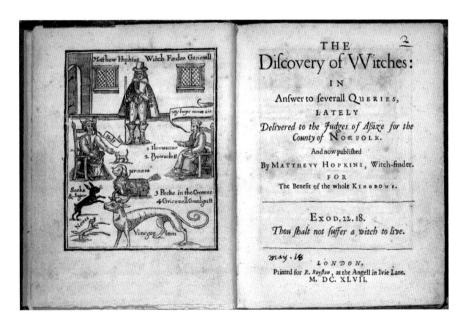

English witch hunter Matthew Hopkins outlined witchcraft investigation strategies like "searching" and "waiting" in his 1647 book *The Discovery of Witches*, which influenced investigations in Connecticut and other colonies.

1. A proud look
2. A lying tongue
3. Hands that shed innocent blood
4. A heart that devises wicked plots
5. Feet that are swift to run into mischief
6. The uttereth of lies from a deceitful witness
7. Discord that has been soweth among brethren

Some recountings of Mary's story say she was pregnant when convicted, her execution delayed until her son was born, and that the jailor's son Nathaniel agreed to raise the boy until he was twenty-one. There's no evidence any of this is true, though it makes for a dramatic story.

What there is evidence of, in Connecticut and throughout New England, is that Mary and all those accused of witchcraft were put through an interrogation that—even without tactics like sleep deprivation and those outlined in *The Discovery of Witches*—would make it almost impossible not to confess to at least some degree of sin. Said Reis in the *Organization of American Historians Magazine of History*: "[Women] implicated themselves unwittingly because they admitted being sinners. They were unable to convince the court and their peers that their souls had not entered into a covenant with the devil; they could not wholeheartedly deny a pact with Satan when an implicit bond with him through common sin was undeniable."

In other words, some women just broke, as perhaps it was for Mary. But her breaking only bolstered Connecticut colonists' beliefs that witches were walking and living among them.

CHAPTER 4

Dangerous Brew

The Hartford and Fairfield Witch Panics

I saw this woman, Goodwife Seager, in the woods with three more women and with them I saw two black creatures like two Indians but taller. I saw likewise a kettle over a fire. I saw the women dance around these black creatures and while I looked upon them, one woman, Goody Greensmith, said Look who is yonder? Then they ran away up the hill. I stood still and the black things came toward me and then I turned to come away.
—testimony against accused witches Elizabeth Seager and Rebecca Greensmith, both of Hartford

Alse Youngs. Katherine Palmer. Mary Johnson. Joan and John Carrington. Goody Basset. Goody Knapp.

These names represent the first seven people accused of witchcraft in the Connecticut Colony. Six of them were tried, found guilty and hanged.

In all, the Connecticut Colony executed eleven of the thirty-four people indicted for witchcraft. This one-in-three ratio gives Connecticut the dubious honor of being New England's—and all of colonial America's—most ferocious witch hunter. "Given [the Puritan's] worldview—that magic was extremely dangerous, extremely powerful and that there were people in league with the devil to use magic against them—you can at least understand why witchcraft was a complicated and dangerous affair," said Connecticut state historian Walter Woodward.

Although Connecticut began executing witches in 1647, and documented witchcraft accusations continued into the early 1720s, the colony's witch hysteria can be divided into two distinct periods: the Hartford Witch

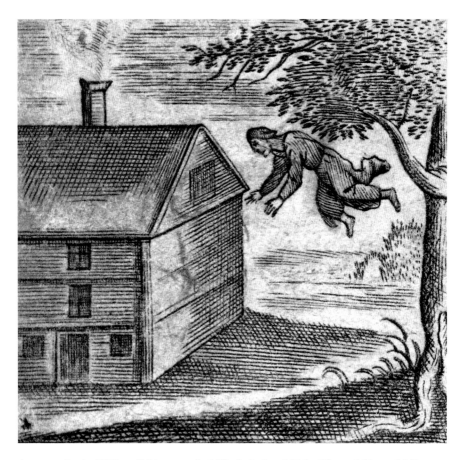

An engraving by William Faithorne called *The Levitation of Richard Jones of Shepton Mallet*, which appeared in the widely distributed *Sadducismus Triumphatus; Or, A Full and Plain Evidence Concerning Witches and Apparitions*. Published in 1681, it included instructions on how to effectively identify a witch, which were used by colony prosecutors.

Panic of 1662–63 and the Fairfield Witch Panic of 1692. In between these two intense time spans were twenty-nine relatively quiet years without an execution, thanks in great part to then-governor John Winthrop the Younger. A physician and alchemist, John Winthrop Jr.—the son of colony founder John Winthrop Sr.—probably believed in witchcraft, but he was not convinced everything unexplainable was caused by diabolical forces. His vocal concerns and protests over the colony's aggressive and in some cases all-too-eager desire to prosecute accused witches eventually resulted in greater skepticism and, ultimately, the end of the trials—though not before a total of nine women and two men died.

Only three people were executed in the later years of Connecticut's forty-five years of witch hysteria. The majority were charged and hanged at its onset, including those first six among the first seven charged:

- Alse Youngs of Windsor for charges unknown. No records exist.
- Mary Johnson of Wethersfield, who confessed to "familiarity with the Devil," among other crimes.
- Joan and John Carrington of Wethersfield, the first of seven husband-and-wife couples accused. Both were charged with "familiarity with Satan" and "works above the course of nature."
- Goody Basset of Stratford for charges unknown. No records exist.
- Goody Knapp of Fairfield, who was arrested shortly after Goody Basset claimed there was "another witch in Fairfield." Although her exact charges are unknown, she was found to have "witch marks" for imps and familiars to suckle, court records state. On the day of her death, Goody Knapp refused to indicate anyone else, warning her executioners to "take heed the devils have not you!" (More on her in Chapter 5.)

The seventh person accused, Katherine Palmer of Wethersfield, was not hanged. Accused in 1648 of using witchcraft to torment a neighbor, Katherine was released from prison with a warning. During the Hartford Witch Panic, which began in March 1662, Katherine was brought up on witchcraft charges a second time for her involvement in the unexpected death of eight-year-old Elizabeth Kelly, which occurred shortly after Elizabeth walked home from church with neighbor Judith Ayers. Scared of what the trial would bring, Katherine fled to Rhode Island.

THE HARTFORD WITCH PANIC OF 1662–63

The 1660s were a particularly difficult time in Connecticut. After an overthrow in England by military leader Oliver Cromwell, King Charles II had been restored to the throne, and the likelihood of Connecticut being established as an independent colony, rather than continue as an offshoot of the Massachusetts Bay Colony, was tenuous. Colonists anxious for Connecticut to receive a charter were fighting with those leading New Haven, who were balking at swearing allegiance to Charles. Because of this, members of several of the small villages surrounding New Haven were lobbying to leave New Haven's jurisdiction and become part of the Hartford Colony instead. But

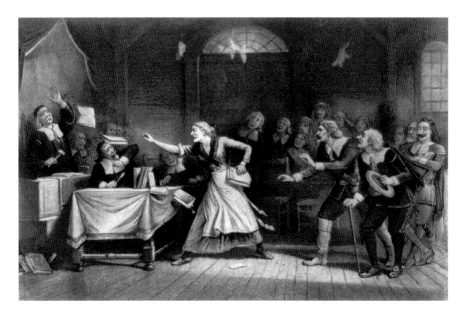

Lithograph *The Witch No. 3*, published by George H. Walker & Company of Boston and New York in 1892. *Library of Congress Prints and Photographs Division.*

Hartford was suffering its own discontent. A rift between Hartford church elders and senior minister Stone had caused several leading families to move north to Hadley, Massachusetts. The absence of John Winthrop Jr. and his moderate voice—he was on his way to England to negotiate a charter—meant the mood was one more focused on discord than discussion.

Elizabeth Kelly's tragic death only made things more unsettled, especially after her parents' heartbreaking testimony. Handwritten in difficult scrawl, the document transcribing the words John and Bethia Kelly allegedly spoke show Elizabeth "was in good health as she was for a long time" until Judith Ayers "required" her to eat some hot broth. Shortly after, Elizabeth began suffering from stomach cramps, her parents said. John Kelly gave the first part of this testimony:

> *I gave her a small dose of the powder of angelica root which gave her some present ease. We did at that present wonder the child should eat broth so hot, having never used so to do, but we did not then suspect the said Ayers.*
>
> *In the afternoon on the same day the child went to the meeting again and did not much complain at her return home, but three hours in the night next following the said child being in bed with me, John Kelly, and asleep did*

suddenly start up out of her sleep and holding up her hands cried: Father!
Father! Help me! Help me! Goodwife Ayers is upon me. She chokes me.
She kneels on my belly. She will break my bowels. She pinches me. She will
make me back and blue. Oh father! Will you not help me! And some other
expressions of like nature to my great…astonishment.

My reply was, Lie you down and be quiet. Do not disturb your mother.
Whereupon she was a little quiet, but presently she starts up again, and
cried with greater violence than before against Goodwife Ayres using much
the expression aforesaid.

Then, rising, I lighted a candle and took her up and put her into bed
with her mother, from which time she was in great misery, crying out against
the said Ayres and that we would give her a drink.

On Monday crying out against the said Ayres saying Goody Ayres
torments me! She pricks me with pins! She will kill me! Oh father, set on
the great furnace and scald her! Get the broad axe and cut off her head. If
you cannot give me a broad axe, get the narrow axe, and chop off her head.
Many like expressions continually proceeding from her.

We used what physical helps we could obtain, and that without delay,
but could neither conceive, nor others for us, that her malady was natural.

In this sad condition she continued till Tuesday. On which, I, Bethia
Kelly, being in the house with the wife of Thomas Whaples and the wife
of Nathaniel Greensmith, the child being in great misery, the aforesaid
Ayres came in. Whereupon the child asked Goody Ayres, Why do you
torment me and prick me? To which Goodwife Whaples said to the child,
you must not speak against Goody Ayres. She comes in love to see. While
the said Ayres was there, the child seemed indifferent, well and fell asleep.
The said Ayres said, she will be well again, I hope.

The same Tuesday at night the child told us both that when Goody
Ayres was with her alone she asked me, Betty why do you speak so much
against me. I will be even with you for it before I die, but if you will
say no more of me, I will give you a fine lace for your dressing. I, Bethia
Kelly, perceiving her while being with the child and thinking she promised
her something. I asked her what it was. The said Ayres answered, A lace
for a dressing.

Court records continue, saying Elizabeth was quiet until midnight. Then, she began calling out again, asking that her father make magistrates punish Goody Ayres for "how she misuses me." The following day, Elizabeth proclaimed, "Goody Ayres chokes me," and died.

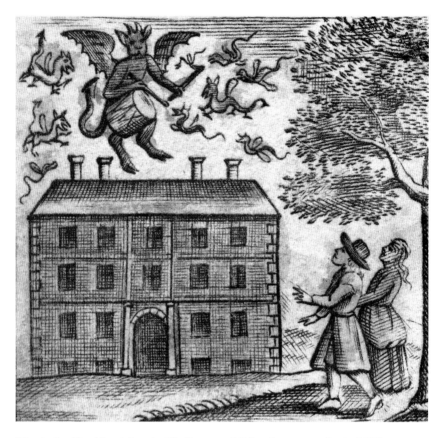

The devil calling his minions in *The Drummer of Tedworth*, an engraving by William Faithorn in Joseph Glanvill's *Sadducismus Triumphatus* witch-hunting guide.

An examination of Elizabeth's body shortly after death showed that the backsides of her arms were black and blue, and when they turned her to her side, the stench that rose caused two of the magistrates to leave the room. It was also noted that instead of her body being stiff, her arms were still limber, and a large red spot had appeared on her cheek, near where Goody Ayres stood in her bedroom. These facts suggest that those who attended the examination of Elizabeth's body may not have been familiar with the physical changes that occur after death, including the time frame for rigor mortis (stiffening of the body) and the occurrence of livor mortis (the pooling of blood in certain parts of the body).

Overwrought, John Kelly refused to allow his daughter to be buried until it was decided whether witchcraft was or wasn't the cause of death. But

with Winthrop in England, they were without a physician to offer a medical opinion. Officials sent for Guilford physician Bryan Rossiter, who was friends with Winthrop and well known by several of the Hartford magistrates. Arriving five days after Elizabeth died, Rossiter performed an autopsy at her graveside. Historians say it was the first complete autopsy performed in Connecticut, as well as the first autopsy in colonial America to be performed as part of a witch trial.

Yet whether it was an informed autopsy is another story. If Rossiter was a proper physician, with proper medical training, he must have missed the lessons on death and decay, because the "six particular…preternatural" findings he noted were all natural occurrences for an almost week-old corpse. These include the facts that Elizabeth's "whole body; the musculous parts, nerves and joints were all pliable, without any stiffness or contraction… Experience of dead bodies renders such symptoms unusual. [Also]…no quantity or appearance of blood was in either venter or cavity such as breast or belly, but in the throat only [and]…in the backside of the arm."

Even with aggressive witch prosecutors like the First Church's Reverend Stone on the case, it took more than a month for formal charges to finally be brought against Goody Ayres, to which she rightly exclaimed, "This will take away my life!" Present for the indictment hearing, neighbor Elizabeth Seager (who between 1663 and 1665 would be accused for witchcraft three times) shushed Goody Ayres, telling her through clenched teeth to "Hold your tongue," court records show.

During the trial, neighbor Joseph Marsh testified that he heard Goody Ayres tell Elizabeth Kelly, in whispers, that she would bring Elizabeth lace for her dresses if she would stop accusing her. Two other neighbors, Anne and Samuel Barr, also told magistrates of a story Goody Ayres once told them about when she lived in London. A handsome young man had come to court her, and she promised to meet him at a set place and time. However, when she looked down, she saw he wasn't wearing shoes and, instead of feet, he had the cloven hoofs of the devil. Because of this, she did not keep their date. When she didn't show up, the man got so angry he ripped the iron bars off a nearby gate.

This "evidence" of an earlier acquaintance with a creature that could have been the devil only made Goody Ayres appear more guilty, as did the fact that her husband, William, had been arrested and convicted of stealing a cow and hog, as well as fined for several misdemeanors.

It's possible that suspicions of William Ayres's involvement in witchcraft became part of the trial because, based on writings of Puritan leader and

While most witches convicted in the Hartford area were likely hanged from gallows erected in the Hartford Colony's south pasture, located somewhere in the vicinity of today's Dutch Point, some may have also been hanged in Meeting House Square, now the location of the Old State House.

government official Increase Mather (father of Cotton), it appears that both Goody and William Ayers were forced to take the water test. In *Essay for the Recording of Illustrious Providences*, Increase Mather cites a man and woman in Connecticut who, "when laid upon the water, swam after the manner of a buoy"—a sign of guilt, because they did not sink into the "pure" water.

Mather goes on to explain how the couple "fairly took their flight, not having been seen in the part of the world since," which is exactly what the Ayreses did. With the help of friends, Judith Ayres broke out of prison, and she and her husband fled to Rhode Island, leaving everything—including a five- and eight-year-old son—behind. Village leaders sold off their farm to pay their debts.

More than three hundred years after Elizabeth Kelly's death, the *Journal of the American Medical Society* wrote about the case, which *Hartford Courant*

medical reporter Frank Spencer-Molloy cited in an October 1993 story about the two-hundred-year anniversary of the Connecticut Medical Society. In the article, then Connecticut chief medical examiner H. Wayner Carver II said colonial physician Bryan Rossiter made "a bunch of screwups." Most of what Rossiter described as "preternatural" findings are consistent with what a physician should expect to find on a five-day-old corpse. Killing her was in all likelihood not witchcraft, but a combination of pneumonia and sepsis, the latter being a toxic and often-fatal blood infection that commonly causes delirium. Elizabeth's complaints about Goody Ayers sitting on her chest, making breathing and swallowing difficult and painful, may have been due to a condition called achalasia, Carver said, which causes abnormal contractions of the esophagus. With achalasia, swallowing solids would be "exceedingly painful," and the patient would suffer from aspiration: the breathing in of her own secretions.

Yet as dramatic as Goody Ayers's trial was, it was far from being Connecticut's or Hartford's grand finale. In all, eleven people were accused of witchcraft during the Hartford Witch Panic, with four executed. Those who survived included Judith Varlet, Goody Ayers, Andrew Sanford, James Wakeley and Elizabeth Seager, all of Harford, as well as Elizabeth and John Backleach of Wethersfield. Those executed include Hartford colonists Mary Sanford (Andrew's wife) and Rebecca and Nathaniel Greensmith, along with Mary Barnes of Farmington.

Although accusations and trials continued into the early eighteenth century, Mary Barnes's witchcraft execution in January 1663 was Connecticut's last, something Stanley-Whitman House executive director Lisa Johnson has spent much of her career working to better understand. Although it's not entirely clear how Mary was accused, it's likely she was named by someone involved in one of the other Hartford cases. She spent three weeks in jail before she was hanged.

"Two of the things we know for sure about Mary," Johnson added, "was that she was illiterate and a servant. We also know that at some point, she was accused of adultery, another capital offense at the time, and she was not accepted as a member of the Farmington church, which means its congregation saw her as unworthy. She also earlier accused someone else of witchcraft, so all those things combined could have put her on the witch radar."

CHANGING TIDE

However, even before the Greensmiths (discussed further in Chapter 5) and Mary Barnes were hanged, a hesitation about how and why people were being convicted for witchcraft was beginning to seep across Connecticut. The result was almost thirty years without an execution, thanks in large part to Connecticut governor John Winthrop Jr., who, as both a physician and alchemist, wasn't convinced that everything unexplainable was diabolical. Success at alchemy—the ancient art of turning lead and other substances into gold—required a belief in the occult and the alchemist to have the ability to manipulate natural elements. Practitioners like Winthrop believed in magic, but also in the essentialness of proof and precision. As first a magistrate and then colony governor, he saw little proof or precision occurring in the witchcraft trials and had grave doubts about the outcomes of certain cases. He also believed that not all magic was evil. The result was him becoming a vocal proponent for judges and ministers to handle witchcraft accusations with more open minds.

Upon his return from England, he argued that witnesses should no longer be allowed to submit testimony about ghosts, dreams or other forms of one-sided—and potentially unreliable—spectral evidence against those accused of witchcraft. Also at his insistence, no longer could just one person supply damning evidence about witnessing a witches' sabbat or other rite. For a conviction for this capital offense, "a plurality of witnesses must testify to the same fact," which for the first time shifted the burden of proof from the defense to the prosecution.

After this, between 1664 and 1691, twelve people were tried as witches, yet none of them were executed. Those accused included a young father who made "odd statements" and was said to use witchcraft to kill his newborn daughter, a wife whose husband later admitted to being unfaithful and wanting to divorce her, a woman said to bewitch and cause the death of another and another woman said to admit she could fly. That last woman, Elizabeth Seager of Hartford, was found guilty, but Winthrop requested her sentencing be put on hold while "obscure and ambiguous" issues were clarified. A year later, a special Court of Assistants under Winthrop's leadership decided the following: "Respecting Elizabeth Seager, this court, on reviewing the verdict of ye Jury and finding it doeth not legally answer the Indictment do therefore discharge set her free from further suffering or imprisonment."

THE
CHARTER
Granted by
His Majesty
King CHARLES **II.**
TO THE
Governour & Company
OF THE
English Colony
OF
CONNECTICUT
IN
New-England
IN
AMERICA.

NEW-LONDON:

Printed and Sold by *Timothy Green*, Printer to
the G O V E R N O U R and C O M P A N Y of
the Colony abovefaid. 1 7 1 8.

When Governor Winthrop traveled to England in 1663 to obtain the colony's official royal charter from King Charles II, Connecticut's witch panic reached its peak with eight trials in eight months. This copy of the original charter was printed by Connecticut's Timothy Green in 1718.

FAIRFIELD WITCH PANIC OF 1692

Fear, however, has the power to sweep even the most rational thoughts aside, and flames can spark even a dying fire. Led by Puritan ministers worried about what they saw as a growing moral laxness and willingness to believe only "what they see and feel," another witchcraft hysteria in 1692 erupted simultaneously in both Connecticut and Salem, Massachusetts. Similar to the case of Elizabeth Kelly and Goody Ayers in Hartford, which led to others also being accused of witchcraft, one young girl sat at the heart of the Fairfield Witch Panic: a seventeen-year-old French servant named Catherine Branch.

Employed by the Westcott family and living with them near what is today the Wescott Cove section of Stamford, Catherine (also recorded in some places as Katherine or Kate) was said to be picking herbs when she began to feel pricking in her chest and fell to the ground, convulsing, weeping and swallowing her tongue. In the twenty-first century, those symptoms would almost immediately be diagnosed as epilepsy. But in the seventeenth century, they were diagnosed as the result of witchcraft.

Soon, Catherine began to have visions of cats that talked to her, asking her to attend a banquet with them, promising her gifts if she followed them and threatening to throw rats at her and kill her. Three weeks into having intermittent episodes of these fits, Catherine began seeing the figure of a woman wearing a silk hood and blue apron standing outside the house and calling out "a witch, a witch." Then, she saw a hag-like old woman standing outside dressed in a coat made of homespun wool with two firebrands on her forehead. Soon after, a local woman named Elizabeth Clawson appeared to her sitting on a spinning wheel or the back of a chair. Then, she saw more familiar faces—some she could identify, some she couldn't—including the face of a Fairfield woman named Mercy Disborough (also recorded in some places as Disbrow). Although Catherine had never met Mercy, Catherine's employers, the Westcott family, had had disagreements with both the Disborough and Clawson families.

Fairfield neighbors at first were skeptical that witchcraft was affecting Catherine. But Daniel Westcott, a sergeant in the colonial militia, insisted that witchcraft was the cause, and that those bewitching Catherine be prosecuted. Catherine's testimony led to charges against Elizabeth, Mercy and a woman named Goody Hipshod.

Few references to Goody Hipshod exist, but records show that both Elizabeth and Mercy were brought before magistrates for questioning.

From the trial of Elizabeth Clawson of Stamford, October 1692. *Samuel Wyllys Papers, Brown University Archival and Manuscript Collections.*

Elizabeth testified that she and Daniel Westcott had argued several years earlier, but Mercy said she'd never heard of anyone named Catherine Branch. To help clarify the matter, Catherine was brought into the room, and immediately, records say, she fainted. When she woke, she looked at Mercy; said, "I'm sure it is her"; and began convulsing.

Although no witch marks were found on Mercy, a wart was found on one of Elizabeth's arms, along with something that looked like a one-inch teat near her genitals. Both were jailed and, at Mercy's request, given the water test. Mercy was sure she would sink—proving her innocence—but both she and Elizabeth floated "like corks," even when men worked to push them under the water.

Magistrates urged the two to confess, but at the same time, several neighbors questioned Catherine's accusations. Although Mercy, who lived in the Compo section of Fairfield, was mostly unknown to those who lived near the Westcotts, Elizabeth was well known and well liked in Stamford—so much so that seventy-six Stamford residents signed a petition stating that Elizabeth had never acted maliciously toward her neighbors or used threatening words. Her husband, Stephen, also vigorously defended her.

But Mercy had no champions. While being held in jail, dozens of people came forward to speak against her, accusing her of killing cows and

Testimony from the trial of Mercy Disborough of Fairfield, June 1692. *Samuel Wyllys Papers, Brown University Archival and Manuscript Collections.*

bewitching a pregnant woman so that her infant would be born ill. Two young men also claimed that, after the water test, they heard her assert that if she hanged, she wouldn't hang alone.

"New Englanders have a reputation of being trigger-happy, believing that being accused is the equivalent of being found guilty and executed, but that's not what happened in Stamford," author Richard Goodbeer told the *Stamford Advocate* for an article about the release of his 2005 book *Escaping Salem: The Other Witch Hunt of 1692.* "It's really tempting when you look at someone like Kate Branch to ask, 'Well, what was really going on? Was it epilepsy?' But I would argue that's precisely the wrong question to be asking. Whether witchcraft exists, or Kate Branch was faking or an epileptic…is the very least interesting thing one could possibly think about. What matters is understanding what people believed and thought was going on, and what shaped their behavior."

Yet even with Mercy and Elizabeth in jail, Catherine's fits and accusations continued. Catherine accused at least four additional women of being witches, including one named Goody Miller, who fled to live in New York, outside of the Connecticut Colony's jurisdiction. None of the other accusations stuck,

however, and in September 1692, it was just Mercy and Elizabeth brought before a grand jury for trial. A second body search for witch marks found a "suspicious" growth on Mercy and nothing on Elizabeth, except for the comment that her body was "made differently." But when the trial began, only Catherine could cite any current wrongdoings committed by the two.

Witnesses spoke primarily about events that had occurred in the past. Daniel Westcott testified that several years earlier, after his wife and Elizabeth Clawson argued, his eldest daughter became ill, screamed at night and claimed to see a pig in her bedroom. Abigail Westcott confirmed her husband's testimony, as well as said that Elizabeth had once thrown a rock at her and called her a "proud slut." Witnesses against Mercy included a young man who said Mercy once declared "if she had but strength she would teer me in peses" and later attacked him in a dream. Another young man claimed that while having dinner at Mercy's house, he began to hallucinate, seeing the roasted pig both with and without any skin. During dinner, he and Mercy also disagreed about a Bible scripture, and then on his way home, he could not make his horse walk a straight line.

But not all testimonies benefited the prosecution. Two men said they were at the Westcott house when Catherine went into one of her fits, and when they said they were going to use a sharp knife to bleed her, her convulsions stopped. Catherine also told them that even though she saw the faces of Elizabeth Clawson and others, they might not all be witches. Another woman named Sara Ketchum testified she didn't believe Catherine's fits were real, and to prove it, she and a man named Thomas Austin conducted a test.

According to Sara, Thomas told Catherine that when a person is bewitched, having a naked sword held over his or her head will cause the person to laugh him or herself to death. When he held a sword over her head, she broke out into uncontrollable laughter. Later, when a sword was held over Catherine's head without her knowing, there was no laughter or any change in her expression. Sara Ketchum also testified she heard Daniel Westcott say he could make Catherine "do tricks." Another woman claimed to have seen Catherine bury her head into a pillow to hide her laughter when Abigail Westcott began to cry over Catherine being bewitched.

The jury could not reach a verdict. Elizabeth and Mercy were sent back to jail, and a second trial resumed a month later. Like the first, it began with a body search for witch marks. This time, the women conducting the search found on Elizabeth Clawson's "secret parts, just within ye lips of ye same, growing…something an inch and a half long in the shape of a dog's ear which we apprehended to be unusual to women." On Mercy Disborough, they found

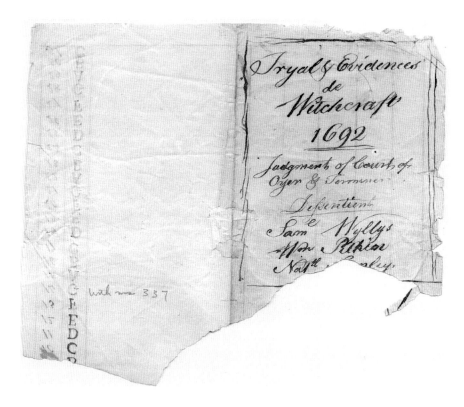

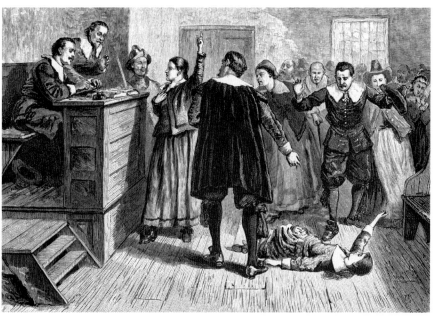

"on her secret parts, growing within ye lip of same, a loose piece of skin and when pulled it is near an inch long. Somewhat in the form of ye finger of a glove flatted. That loose skin we judge more than common to women."

Elizabeth was found not guilty and ordered released from jail, provided she pay the jailer for her expenses. Mercy was found guilty of familiarity with Satan, along with conspiracy to "impute in a prenatural way the bodies and estates of divers of His Majesty's subjects."

An appeal was submitted for Mercy, and three magistrates granted a stay of execution until the next Generall Court met in Hartford. A group of clergymen also drew up a lengthy statement denouncing the methods used in her trial. Mercy additionally gained the support of powerful minister, physician and politician Reverend Gershom Bulkeley of Glastonbury, who believed the people of Connecticut were being illegally and unfairly governed. He decided to use her case as part of his argument, incorporating it into his book *Will and Doom; or the Miseries of Connecticut by and Under an Usurped and Arbitrary Power*. His words, coupled with those from the magistrates, led to Mercy receiving a pardon. Wrote Bulkeley:

> *I cannot understand of anything brought in against* [Mercy] *of any great weight to convict a person of witchcraft, yet some of the court were very zealous...The execution suspended till next General Court...is the wisest act they have done since the revolution...The reprieve is better than the judgment, because it prevents a mischief...*[These] *cases are enough to prove...that not only our estates and bodies, but our lives also, are at the disposition, not of the King and his laws, but of this pretending, usurping corporation, and in what hazard they area. Our foundations being thus removed and out of course, what can the righteous do? It is a great scandal.*

One of Mercy's descendants, Stephen Squires, addresses this "scandal" and the long-standing impact of Connecticut's witchcraft trials in his self-published booklet *Are There Witches? Being a True Tale of Discovering a Connecticut Ancestor Accused of Witchcraft*, which he wrote in 1995:

Opposite, top: From the Fairfield Panic. *Samuel Wyllys Papers, Brown University Archival and Manuscript Collections.*

Opposite, bottom: *Witchcraft at Salem Village*, an engraving in the book *Pioneers in the Settlement of America: From Florida in 1510 to California in 1849* by William A. Craft, published in 1877 by Samuel Walker and Company.

While Compo seems to have forgotten Mercy and her tribulations…the place itself has absorbed something of her lore nevertheless. In my research, I came upon an elderly gentleman of Compo, unfamiliar with Mercy, who recalled that, in his youth, adults whispered about another "witch" there. She was simply an innocent old woman with an interest in herbs and folk remedies. It was said she grew her herbs and hung them in her barn. Mixed with those shadowy whispers about witchcraft, a gleaming vein of respect shines through this story, for she was also reputed to have been consulted by none other than an early 20th century president! Perhaps he stopped by while passing through Compo in his train, on rails laid very near to her house.

Although Mercy Disborough was the last person in Connecticut to be convicted and condemned to death for witchcraft, she was by no means the last accused.

CHAPTER 5
The Devil's Familiars

Some of the More Infamous Connecticut Witchcraft Cases

Thomas Allyn thou art indicted by the name Thomas Allyn not having the due
fear of God before thine eyes for the preservation of the life of thy neighbor, did
suddenly, negligently and carelessly cock thy piece and carry the piece just behind
thy neighbor, which piece being charged and going off in thy hand, slew thy
neighbor to the great dishonor of God, breach the peace and loss of a member of
this Commonwealth. What say thou, art thou guilty or not guilty?
—indictment of Thomas Allyn of Windsor

Thomas Allyn's answer to the question of whether he was guilty or not guilty of killing neighbor Henry Stiles couldn't be anything but "guilty." Both members of the Connecticut Colony militia (called a trainband in the seventeenth century), the two were taking part in a drill in November 1651 when Thomas' gun accidentally discharged and killed Henry, who was marching in front of him. Thomas had not properly locked the trigger and so confessed to the indictment excerpted above.

A prominent member of the Windsor community, Thomas' trial led to a charge of "homicide by misadventure" imposed by the Hartford Particular Court jury. He was fined twenty pounds for "sinful neglect and careless carriage" and put on the colonial version of parole for twelve months, during which time he could not leave the colony or use a gun. He completed this term successfully. Three years later, however, with no explanation, the court refunded Thomas's fine and charged another Windsor resident, Lydia Gilbert, with killing Henry Stiles by witchcraft:

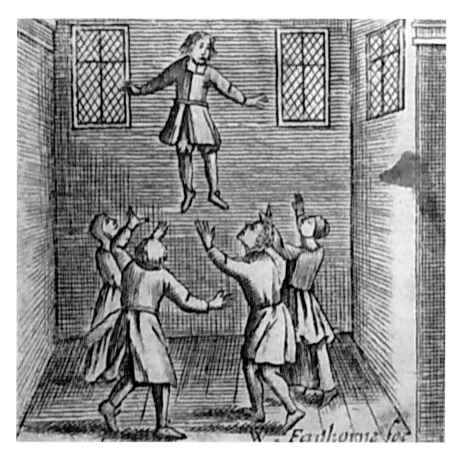

For New England colonists and those living in Europe, images like this one by William Faithorne in *Sadducismus Triumphatus* affirmed the existence of witches and their supernatural powers.

Lydia Gilbert, thou art hereby indicted by that name Lydia Gilbert that not having the fear of God before thine eyes thou hast of late years or still do give entertainment to Satan, the great Enemy of God and mankind and by his help hast killed the body of Henry Stiles, besides other witchcrafts for which according to the law of God and Established law of this Commonwealth, thou deserves to die.

Land and probate records show a connection between Lydia and Henry, who was a carpenter. In January of either 1644 or 1645, Henry's brother Francis sold farmland to Lydia's husband, Thomas, and apparently Thomas

and the Gilberts lived on and operated the farm together. When Henry died, Thomas showed Francis a detailed accounting of his and Henry's business dealings, which showed that Henry owed the Gilberts money.

Whether Henry and the Gilberts had a good or difficult relationship is unknown, as is where the witchcraft charge came from. It's also unknown what evidence was presented during the trial or whether Lydia and Thomas Allyn even knew each other.

What is known is that Lydia's adult son, Jonathan, was marshal in Hartford at the time of her arrest, and he was probably the person sent to read her the charges and take her to the prison house. In the stark room with barred windows, cells were often lighted with iron grease lamps. Shackled with chains, prisoners were allowed to bring minimal furnishings, which generally included a featherbed, throw rug and a blanket. If family members wanted their loved ones in jail to eat well, they paid the jailer more than the minimum required for daily meals, as Lydia's did.

Other notable Connecticut witchcraft cases include the following:

JOHN AND JOAN CARRINGTON

Little is known about this Wethersfield couple, the first husband and wife to be accused of witchcraft. They were indicted in February 1651 by the Particular Court in Hartford, both accused of "familiarity with Satan" and "works above the course of nature." Joan's age is not known, but John was roughly forty-five—a carpenter who two years earlier had gotten in trouble and fined ten pounds for selling a gun to an Indian.

No record of their trial exists, though their names are mentioned in a Massachusetts witchcraft trial later that same year. Hugh Parsons of Springfield, Massachusetts, was tried in Boston after his wife, Mary, accused him of being a witch during a dispute with neighbors. Soon after, distraught and apparently having suffered a mental breakdown, Mary accused herself of being a witch and said she was responsible for the death of her five-month-old baby. During the trial, Mary told magistrates that she began to suspect Hugh of being a witch when he expressed sympathy over news of the Carringtons' case. Her words to Hugh about his alleged guilt:

> *You cannot abide anything should be spoken against witches…You were at a neighbor's house…when they were speaking of Carrington and his wife,*

that were now apprehended for witches…When you came home and spake these speeches, [I said]…I hope that God will find out all suck wicked persons and purge New England of all witches ere it be long…You gave a naughty look…This expression of your anger was because [I said I] wished the ruin of all witches.

Unlike the Parsons, who were both acquitted of witchcraft, the Carringtons were found guilty and executed. In Boston, Mary was found guilty of murdering her infant but died in prison before she could be hanged.

ELIZABETH GODMAN

One of a handful of Connecticut colonists tried for witchcraft more than once, widow Elizabeth Godman (also written in some places as Goodman) of New Haven began drawing attention to herself in 1653 by openly questioning prosecutors' witch interrogation tactics—"Why do they provoke them? Why do they not let them into the church?"—and then daring neighbors to accuse her of being a witch. The result was her being accused twice in two years, first in 1653 and then again in 1654.

Living in the house of New Haven Colony deputy governor Stephen Goodyear, Elizabeth often muttered to herself, neighbors said, and walked from house to house, scolding neighbors and announcing that should the devil decide to come suck one of her nipples, she would not let him. Her behavior led to her undergoing a formal "examination" in 1653, which featured testimony and accusations from a number of neighbors who made a wide array of claims, including that Elizabeth was married to Hobbomock, the evil, mythical giant who lay under the hills of what's now Sleeping Giant State Park in Hamden, Connecticut; that she "cast a fierce look upon Mr. Goodyear" and then he "fell into a swoon"; that when no one was around, she routinely spoke aloud to the devil; and that she was responsible for bewitching her young neighbor Hannah Lamberton, causing the girl to hear noises, feel pinches and suffer from both burning and freezing sensations that made her shriek in pain.

Just two days before Halloween in 1972, *New Haven Register* reporter Harold Hornstein wrote about Elizabeth in his "Our Connecticut" column:

Mrs. Goodman's disposition was regarded as "acrid" and her manners "disagreeable," it was reported by Henry T. Blake in the discussion of

The Wonders of the Invisible World:

Being an Account of the

TRYALS

OF

𝕾𝖊𝖛𝖊𝖗𝖆𝖑 𝖀𝖀𝖎𝖙𝖈𝖍𝖊𝖘,

Lately Excuted in

NEW-ENGLAND:

And of several remarkable Curiosities therein Occurring.

Together with,

I. Observations upon the Nature, the Number, and the Operations of the Devils.

II. A short Narrative of a late outrage committed by a knot of Witches in *Swede-Land*, very much resembling, and so far explaining, that under which *New-England* has laboured.

III. Some Councels directing a due Improvement of the Terrible things lately done by the unusual and amazing Range of *Evil-Spirits* in *New-England.*

IV. A brief Discourse upon those *Temptations* which are the more ordinary Devices of Satan.

By COTTON MATHER.

Published by the special Command of his EXCELLENCY the Govencur of the Province of the *Massachusetts-Bay* in *New-England.*

Printed first, at *Boston* in *New-England*; and Reprinted at *London,* for *John Dunton*, at the *Raven* in the *Poultry.* 1693.

Historians believe the speeches and writings of Puritan minister Cotton Mather made the scared, superstitious mindset of colonial New England even more so. *Library of Congress Prints and Photographs Division.*

her case in his Chronicles of New Haven Green. *The unpopular old woman…was suspect in the eyes of the Rev. Mr. Hooke because she had an unaccountable way of always knowing what had been done at secret church meetings. The minister's Indian servant told of how Mrs. Goodman would, time and again, leave the church meeting, come in again and tell the others what had ensued during her absence. Once, when the Indian asked how she knew what happened, Mrs. Goodman would not explain. "Did not ye Devil tell you?" Mrs. Goodman was asked. The devil also was said to have been in conversation with Mrs. Goodman when the latter had been seen talking to no one in particular.*

The tales of Mrs. Goodman's eccentricities began to proliferate—she knew Mrs. Atwater had figs in her pocket when they had not been displayed; chickens died, being consumed by numerous works after she'd been to a house. Over a period of two years with Mrs. Goodman in jail part of the time, the case dragged on. Finally…the Rev. Mr. Hooke brought in what he thought would be damaging evidence. He told of how Mrs. Goodman, looking extremely dour, had been to his house to "beg some beer." She ungraciously spurned some brew that had been offered her, demanding some that had been newly drawn. Though this request was granted, still she left muttering and discontented. The next morning, said the accuser, his beer was found to be hot, sour and ill-tasting, though it had been fresh the night before.

Alarmed at the prospect of Elizabeth turning other households' beer sour, New Haven magistrates decided it was more important to keep her away from colony residents than to pursue witchcraft charges against her. Although evidence of her being a witch was "clear and strong," there was not enough for a conviction, magistrates said. She was released with a warning to keep to herself and stay away from neighbors, and she was warned that any additional complaints would lead to her being committed to prison.

WILLIAM MEEKER

It was likely a dispute between neighbors that led to witchcraft accusations against William Meeker (in some histories spelled Meaker) of New Haven in 1657. Known for being a troublemaker, Thomas Mullener—who according to the *New Haven Colonial Records* had run-ins with the law for infractions such

as "sending his servants to the oyster banks to gather oysters upon the Sabeth day" and then eating them, stealing pigs and marking them as his own and "borrowing" neighbors' horses and oxen without permission—often quarreled with Meeker and accused him of bewitching one of his pigs. Following "a means used in England by some people to finde out witches," Mullener "cut of the tayle and eare of one [of his pigs] and threw [them] into the fire." The result, it seems, pointed to Meeker.

Meeker disputed the charge, and because of Mullener's reputation, the case was quickly dismissed. Mullener, however, was fined for slandering Meeker. Apparently satisfied with the court's decision, Meeker refused the twenty pounds awarded him, "for it was not his estate he sought, but he might live peaceably" nearby Mullener.

Connecticut journalist Ray Bendici offers an opinion on the case on his Damned Connecticut website. It "gives a great insight to how serious the charge of witchcraft was considered," Bendici said. "Three hundred and sixty years later, and William [Meeker's] name is still on the witchcraft record despite what appears to have been a spurious claim from a crackpot neighbor. Thankfully, it was recognized for that at the time, and [Meeker] didn't suffer the fate that some others accused of the same crime did."

GOODY KNAPP AND MARY STAPLES

One of the most dramatic and contemptuous cases involved Goody Knapp (first name unknown) and Mary Staples, both of Fairfield, which was sparked when one of Goody Knapp's questioners told her to speak before the devil silenced her forever, and Goody Knapp angrily replied: "Take heed the devil have not you, for you cannot tell how soon he might be your companion. The truth is you would have me say that Goodwife Staples is a witch, but I have sins enough to answer for already and I will not add this to my condemnation. I know nothing by Goodwife Staples, and I hope she is an honest woman."

Convicted in 1653 on the presence of "witches teats" to suckle "familiars," Goody Knapp came under suspicion during the trial of Goody Bassett of Stratford (discussed in the Introduction and then again briefly in Chapter 4) and was vocally defended by her neighbor, Mary Staples, who contemptuously told authorities that Knapp had no more teats than any other woman.

One of the earliest known images of witches on broomsticks, from the 1451 manuscript *Hexenflug der Vaudoises*, or *Flight of the Witches*, by France's Martin Le France.

Among the magistrates who tried Knapp was Roger Ludlow, who today is well known and respected as one of the founders of the Connecticut, Fairfield and Norwalk Colonies. Two schools in Fairfield are named after him: Roger Ludlowe Middle School and Roger Ludlowe High School, both of which include an "e" in Ludlowe, as historians say remains of his signature leave a question of whether it was spelled with or without the "e."

A lawyer and military officer, Ludlow was present for Knapp's execution, which many believe took place in what is today the Black Rock section of Bridgeport at roughly 2470 Fairfield Avenue. At the time, it was an empty lot between a house and a mill. What happened at the gallows is best described by R.G. Tomlinson in *Witchcraft Prosecution: Chasing the Devil in Connecticut*:

> *At the execution, Goody Knapp asked to speak with Roger Ludlow, and descended the gallows steps to whisper in his ear before she was hanged. As soon as the body was cut down, Mary Staples rushed forward and demanded to be shown the witch's teats. When no one responded, she seized the body and stripped away the clothes and tumbled the body up and down, pulling on the teats as if to pull them off. She called to Goodwives Odell and Lockwood and others who had been on the committee that searched for witch marks to come and look at the body. The women refused to come, and Mary continued her tirade, wringing her hands and swearing, "…will you say these are witch's teats?...Here are no more teats than I myself have, or any woman…if you but search your body."*

Several days later, Ludlow revealed that at the foot of the gallows, Goody Knapp told him that Mary Staples was a witch and "makes a trade of lying." Incensed, Mary's husband, Thomas, sued Ludlow for slander. During the trial, a key witness named Mr. Davenport told the court he believed the charges were totally untrue and spoken by Ludlow out of malice because Mary would not say Goody Knapp was guilty.

Judges agreed, ordering Ludlow to pay Thomas and Mary Staples ten pounds for calling Mary a liar and ten pounds for calling her a witch. He also owed the court five pounds for trial expenses. Accused by many in the colony of being a narrow and vindictive man, Ludlow angrily left Fairfield for Virginia, taking all the colony's records with him.

NICHOLAS AND MARGARET JENNINGS

Described by one historian as "a rascally pair" long before they were accused of witchcraft in 1661, Nicholas and Margaret Jennings of Saybrook first made news twenty years earlier when the two met in New Haven, fell in love and ran off together. He was a soldier, and she was an indentured servant working for the Turner family. When the two were captured, Nicholas was found guilty of "fornication" and publicly whipped. Margaret was found guilty of fornication and theft, flogged and then ordered by the court to marry Nicholas. The two also had to pay Captain Nathaniel Turner for time lost when Margaret was missing, as well as for the items they stole to fund their escape.

Apparently, "a modest trail of troubles" followed as the two moved to Hartford, including Nicholas being prosecuted for striking a neighbor's cow. They moved to Saybrook, where they had three children and all was quiet until June 1659, when "suspicions about witchery" were lodged. The case was not pursued. But in 1661, shortly after the Jenningses and neighbor George Wood were involved in a land dispute, Wood accused Margaret of being possessed by Satan and the Jenningses' daughter Martha of being pregnant out of wedlock. The indictment read as follows:

> *Nicholas Jennings thou art here indicted by the name of Nicholas Jennings of Saybrook for not having the fear of God before thine eyes, thou hast entertained familiarity with Satan, the great enemy of God and mankind, and by his help hast done works above the course of nature to the loss of the lives of several people and in particular the wife of Reinold Marvin with the child of Baalshassar de Wolfe with other sorceries for which according to the law of God and the established laws of this Commonwealth thou deservest to die.*

Both pleaded not guilty, but the jury could not reach a verdict. Their decision was that Nicholas and Margaret would not be found guilty, but they would also not be cleared.

REBECCA AND NATHANIEL GREENSMITH

Perhaps the single most dramatic moment of Connecticut's witch trials came from Rebecca Greensmith of Hartford, who neighbors called a "leud, ignorant and considerable aged woman." She and her husband, Nathaniel,

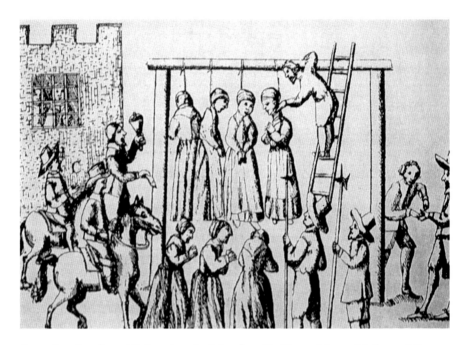

A woodcarving of a public hanging of witches from Sir George Macenzie's *Law and Customs in Scotland in Matters Criminal*, 1678.

were accused of being witches in 1662 by their young neighbor Ann Cole, who suffered from "strange fitts with such extremely violent bodily motions." While Ann was unconscious, her family and community leaders said, demons spoke through her and identified local witches. Interestingly, the seizures only seemed to occur when observers were present.

In court for their indictment hearing, Nathaniel—who previously had been found guilty of stealing wheat, lying and assault—was found innocent and set free. Rebecca went to prison, and perhaps she understood her chances of acquittal were slim. Rather than adamantly maintain her innocence, she confessed not just to being a witch but also to her part in a diabolical coven of witches that included her husband and began when the devil first appeared to her in the form of a skipping fawn in the woods. The coven danced and drank in woods near her house, she said, where she had sex with the devil, and other witches appeared in different forms, including one who could fly like a crow and another who pranced like a cat. She had not yet given her soul to the devil, she said, but planned to as part of a "merry meeting" on Christmas Day.

Learning what she planned to say, Nathaniel begged her before the trial to not implicate him, promising that if she was found guilty and executed,

he would take good care of her two teenaged daughters from a previous marriage. Clearly, however, Rebecca had no intention of dying alone. Obviously embellishing every detail, she told magistrates that although she was reluctant to speak against her husband, it was the only way for the Lord to open up his heart to her. Here is her confession:

1. That my husband on Friday night last, when I came to prison, told me that now thou hath confessed against thyself, let me alone. Say nothing of me and I will be good unto they children.

2. I do now testify that formerly, when my husband told me of this great travail and labor, I wondered how he did it…and he answered that he had help that I knew not of.

3. About three years ago, as I think, my husband and I were in the woods several miles from home and were looking for a sow that we lost and I saw a red creature following my husband. When I came to him, I asked him what it was that was with him and he said it was a fox.

4. Another time when he and I drove our hogs into the woods, beyond the pound that was to keep young cattle, I went several miles to call the hogs and, looking back I saw two creatures like dogs, one a little blacker than the other. They came to my husband pretty close to him and one seemed to touch him. I asked him what they were and he told me he thought they were foxes. I was still afraid when I saw anything because I heard so much about him before I married him.

5. I have seen logs that my husband hath brought home in the cart. Being a man of little body and weak to my apprehension and the logs such that I thought two men such as he could not have done it.

I speak all this out of love to my husband's soul and it is much against my will that I am not necessitated to speak against my husband. I desire that the Lord would open his heart to own and speak the truth.

A month later, with such "truths" on the table, both Rebecca and Nathaniel were hanged as witches.

CHAPTER 6
New Incantation

A Quiet Cry to Stop the Witch Hunts

Ye authors warn jurors, etc not to condemn suspected persons on bare presumptions without good and sufficient proofs. But if convicted of that horrid crime, to be put to death, for God hath said, thou shalt not suffer a witch to live.
—excerpt from the Connecticut Colony's Grounds for Examination of a Witch

The word "witch" comes from the Old English word "wicca," which was formed from the Germanic root "wic." It means to bend or turn. By the very origin of their name, then, witches were those who used magic to bend or turn people and events. During the 1600s, Connecticut governor John Winthrop Jr. also used a form of magic to bend Connecticut colonists' thinking about witchcraft, playing what undoubtedly was the most significant role in helping end Connecticut's witch executions. He used the magic of reason.

A physician, alchemist and astronomer, Winthrop's skepticism about the presences of witches came not so much from a disbelief in magic but a practical understanding of the difference between natural and diabolical magic. Intelligent, inquisitive and diplomatic, Winthrop was deeply interested in science and saw magical processes like alchemy as not just self-serving practices but philosophies that led to greater understanding of chemistry, physics, religion and other aspects of the world. Responsible for bringing the first telescope to New England, Winthrop was also famous for his medical skills, which included an innate ability to diagnose illnesses and prescribe the correct combination of herbs to cure what in some instances were never-before-seen ailments.

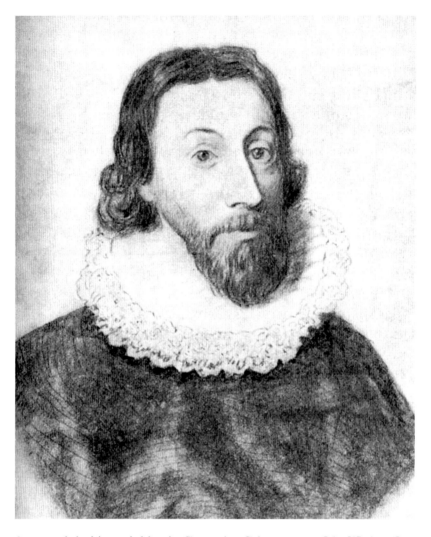

A respected physician and alchemist, Connecticut Colony governor John Winthrop Jr. believed people were too quick to attribute "natural misfortunes" to Satan or the occult and spearheaded efforts to end Connecticut's witchcraft executions.

As curious as he was well spoken, Winthrop saw science and nature as complex, powerful forces that people both overestimated and unnecessarily feared. Magic and witchcraft, he believed, were viewed the same way.

Said historian Walter Woodward in *Prospero's America: John Winthrop, Jr., Alchemy, and the Creation of New England Culture, 1606–1676*:

As a consultant on witchcraft cases in New Haven prior to becoming Connecticut's governor, and then as chief magistrate in Connecticut witchcraft trials, Winthrop consistently refused to accept witchcraft charges, resisting both popular and ministerial pressure to convict witch suspects. He not only orchestrated acquittals in witchcraft cases, on at least two occasions he flatly refused to enforce convictions, ultimately overturning the guilty verdicts.

Elected governor in 1657 after five years as a legislative assistant, Winthrop, until his death in 1676, was an active player in all aspects of life in the Connecticut Colony, including its witch trials. However, it was his involvement in the trial of Katherine Harrison of Wethersfield that ultimately led to him turning people's beliefs about witchcraft and helping halt what he was sure were unfounded executions.

THE WETHERSFIELD WITCH

Former servant Katherine Harrison married a prosperous farmer and trader named John who, when he died in 1666, left her an estate valued at £1,000. This made her a wealthy woman. The couple had three daughters, and it's clear she had ambitions for both them and herself. Shortly after John's will was read, she asked the courts to increase the "inconsiderate" inheritance her husband left their daughters, as well as guarantee Katherine's use of the family house and farm for the remainder of her life.

Not uncommon for the time, her neighbors, it seems, were jealous and resentful of her new status as landowner. They filed lawsuits against her and began suggesting in public that she had a wicked secret to hide.

One former neighbor wrote the court saying that seven or eight years earlier, Katherine had stolen milk from his cows, but when he attempted to stop her, an invisible force held him stiff until Katherine was gone. Another neighbor named Michael Griswold sued her £150 pounds for slander on behalf of both himself and his wife, Ann. Katherine, he said, had told people that Michael had threatened to hang her and that his soul was damned. She also publicly called Ann "a savage whore" and "other expressions of like nature."

A healer or "cunning woman" known for being outspoken, Katherine was found guilty of the Griswolds' charges and ordered to pay them forty pounds. However, she appealed the verdict and, in the court follow-up, begged for

leniency. Apparently as smart as she was sassy, she told judges she was "a distressed widow, a female, a weaker vessel subject to passion, meeting with overbearing exercises by evil instruments [that caused me to speak]…hasty, unadvised and passionate expressions."

Moved by her seemingly sincere admission, judges reduced her fine to twenty-four pounds. But Katherine was not ready to move on. She complained to the court that she was the victim of angry and vindictive neighbors who had attacked her in countless ways. In recent months, she said, someone had beaten two of her oxen, leaving one useless. People had crept onto her property and broken the back and two ribs of one of her cows, destroyed much of her crops and brazenly assaulted a cow standing just outside her front door.

However, what Katherine didn't know at the time she made these complaints was that her neighbors were also working behind her back to collect written depositions that would accuse her of witchcraft. Once completed, the stack of testimonies compiled over many months from both former and current neighbors accused Katherine of being a witch notorious for everything from lying to being a fortuneteller.

A Hartford man named Thomas Whaples said that when Katherine was living and working in Hartford, she used her supernatural powers, engaged in "evil" conversations and was named by convicted witch Rebecca Greensmith as being part of her coven.

A former co-worker claimed only witchcraft would allow Katherine to spin the amount of fine linen she was able to complete.

A tailor who once publicly said Katherine might be a witch said she came to him in a dream, threatening to get even and debating whether to slit his throat or strangle him before beginning to pinch and torment him. He also insisted she bewitched him at work, causing him to incorrectly sew sleeves on a jacket seven consecutive times and wrongly cut two halves of a pair of pants from different-colored cloth.

Another said she made a calf's head vanish from the top of a cart of hay and used the strange words "Hoccanum! Hoccanum! Come Hoccanum" to call her cows, which would race toward the house with their tails on end.

One neighbor said he had seen her make bees fly back to their hives and that she afflicted people she was angry at with chronic nosebleeds and burning sensations in their heads and shoulders.

A twenty-year-old described how, over two months, the image of an ugly dog with Katherine's face would appear in her bed at night, crushing her stomach and threatening to murder her.

Without a son, brother or father to stand up for her against these claims, Katherine was alone, at risk and in many ways defenseless, said author Carol Karlsen in *The Devil in the Shape of a Woman: Witchcraft in Colonial New England*. Katherine was "vulnerable," Karlsen said. "Within the [Puritan's] patriarchal system, women were frequently drawn into lawsuits aimed at depriving them of their estates. For Katherine Harrison, it [led to charges of] witchcraft."

By the time Katherine was brought to trial in 1669, dozens of claims of maleficium had been lodged against her, including those by former patients who said she used her knowledge of herbal medicine to hurt rather than heal. Despite the detailed testimonies submitted about her alleged actions, her formal court indictment was surprisingly nondescript:

> *Katherine Harrison, thou standest here, indicted by ye name, Katherine Harrison of Wethersfield, as being guilty of witchcraft for that thou, not having the fear of God before thine eyes, hast had familiarity with Satan, the grand enemy of God and mankind, and by his help hast acted things beyond and beside the ordinary course of nature and has thereby hurt the bodies of divers of the subjects of our sovereign Lord the King for which by the law of God and of this corporation thou oughtest die.*

Katherine pleaded not guilty, and despite the number and scope of testimonies, the jury was unable to come to a verdict. Katherine was remanded to prison in Hartford until the case could be resumed, but within days, she was back home in Wethersfield. Seeing her there, thirty-eight outraged neighbors petitioned the court, demanding to know "upon what rightful ground she is at such liberty." They also shared their fear of the "dreadful displeasure of God" and reminded magistrates that Katherine was willing to take the water test, which had not yet been administered.

The signature of John Winthrop Jr., published in 1889 in *Appletons' Cyclopædia of American Biography*, volume 6.

When the trial resumed five months later, Katherine was found guilty. But instead of being sentenced, her case was put on hold at the insistence of John Winthrop who, as governor, also served the court as head magistrate.

A man of science and reason, Winthrop was uncomfortable with the jurors' verdict. Much of the evidence presented against Katherine was spectral, which Winthrop and supporters like the Reverend Gershom Bulkeley of Glastonbury believed was unreliable. Just one person witnessing a diabolical event was no more than hearsay, they believed. "A plurality of witnesses must testify to the same fact" for it to be reliable, Winthrop stated.

CHANGING SPIRITS

Gradual realizations about the need for changes in how witchcraft cases were tried—and Winthrop's determination to help make it happen—had been brewing for several years.

Although Winthrop was not a magistrate for the 1665 trial of Elizabeth Seager of Hartford, he deliberately involved himself in the case, which represented the third time Elizabeth was accused of witchcraft. Three years earlier, when Elizabeth was first charged, Winthrop was away in England, working to negotiate an official charter for the Connecticut Colony. Then, although more than half the jurors on the case believed she was guilty, there was not enough consensus to execute her, so she was freed. Brought back to trial a second time in 1663 for witchcraft, speaking blasphemy and adultery, jurors only found evidence to convict her on the adultery charge.

For this third case in 1665, Winthrop was also not in the courtroom when the indictment was read:

> *Elizabeth Seager thou art indicted by the name Elizabeth Seager, the wife of Richard Seager, not having the fear of God before thine eyes, thou hast entertained familiarity with Satan the Grand Enemy of God and mankind and hast practiced witchcraft formerly and continuest to practice witchcraft for which, according to the law of God and established law of this corporation, thou deservest to die.*

As governor, however, Winthrop paid careful attention to both the trial proceedings and its effects on the community. What was it that caused neighbors to make public accusations against this woman three different

times? Observing the proceedings, he heard claims from Hartford residents who said they had seen Elizabeth pray to the devil. A neighbor, Mrs. Mygatt, said that on at least four occasions, she had seen Elizabeth behaving "strangely," including a day when Elizabeth came up behind Mrs. Mygatt as she was feeding her calves, grabbed her arm and said, "How do you? How do you, Mrs. Mygatt." There were claims that Elizabeth had said it was good to be a witch and that the fires of hell would not burn her.

Also not lost to Winthrop was Mrs. Mygatt's testimony that one night, while she was sleeping next to her husband, Elizabeth appeared in the room, seized her hand and struck her in the face. As had occurred at earlier trials, another neighbor claimed he had seen Elizabeth fly through the air.

What Winthrop heard within these testimonies was ignorance, anger and annoyance toward an unpopular and outspoken woman and, though he might not have defined it this way, intolerance for a woman who was clearly different. He also saw how this trial, as others had done, was causing the community to fracture and was creating fear. As writer and historian Carolyn S. Langdon explains in the January 1969 *Bulletin of the Connecticut Historical Society*:

> [Several men], *Governor John Winthrop Jr. among them, had served previously at witchcraft trials, had listened to similar superstitious testimony, had seen accusation lead to accusation as the imaginations of these often unlearned townspeople became fired. Their seemingly frightful accounts were not novel—throughout European history the black cat (or occasionally dog) had been the inseparable mid-night companion of the witch; she had always been able to change her head or her body into animal shapes; to become visible or invisible at will. At her command demons or imps had clutched her victim by the legs and held them fast; she had been familiar with a book from which she derived her unholy knowledge. Such happenings had been commonplace testimony in the hundreds of trials in the English counties from which these people had come. There, as here, in their fear, hatred or envy, neighbors had accused their victim of receiving help from the Devil.*

For the testimonies brought against her this third time, Elizabeth Seager was found guilty. Unconvinced, Winthrop asked magistrates to postpone sentencing until they could clarify what he saw as "obscure" and "ambiguous" proof of Elizabeth's guilt. At Winthrop's urging, a final decision was delayed for three months, and then another eight months, while he shared

his concerns and encouraged other magistrates to do the same. At last, in May 1666, Winthrop called a special session of the Court of Assistants that delivered what would be the final decision in Elizabeth's case, ruling that the indictment should be "discharged" and that Elizabeth should be set "free from further suffering or imprisonment."

Three years later, Winthrop felt the same unease and anxiousness when a guilty verdict was issued for Katherine Harrison. But this time around, he wasn't the only one publicly expressing concern. Like Winthrop and Reverend Bulkeley, other magistrates began to publicly question the types of evidence that should be accepted as clear and actual proof of witchcraft. Determined to use this spark of dissent to affect needed change, Winthrop developed a plan that he hoped would save both Katherine from being hanged and the Wethersfield community from tearing further apart.

Winthrop's answer? Reach out to Katherine, who he asked to respond, in writing, point by point to every charge made against her. He then requested the court appoint a panel of ministers and magistrates to review her responses and consider not just how they should impact Katherine's sentencing, but also how they should impact the way future witchcraft cases were tried.

The panel's answer, though ambiguous in places, sent an overwhelmingly clear message that change was needed. Written by Bulkeley, the panel stated the need for more concrete evidence and shifted the burden of proof from the defendant to her or his accusers. No longer would one witness's testimony of an event be accepted as fact. For future trials, at least two witnesses to every diabolical event would be required. Panel members also questioned the validity of spectral evidence and issued the following statements:

Moving forward, "a plurality of witnesses [must] testify to one and ye same individual fact; and without such a plurality there can be no legal evidence in it." Scripture from John 8:17 was cited as the reason for this change, which says: "It is also written in your law, that the testimony of two men is true." While this first change was not groundbreaking—the need for two witnesses was already an established part of British law—the second was. No longer would claims of specters or apparitions appearing in the form of the accused be allowed as evidence: "It is not the pleasure of the Most High to suffer the Wicked One to make an undistinguishable representation of any innocent person in a way of doing mischief before a plurality of witnesses."

The panel also argued that God would not permit the devil to create an undistinguishable replica of an innocent person: "This would evacuate all human testimony. No man could testify that he saw this person do this or that thing for it might be said that it was ye Devil in his shape."

Part of the confession of Katherine Harrison of Wethersfield, who was tried in May 1669 and, among other charges, was accused of bewitching a cap that caused its wearer to be "afflicted by a burning sensation." *Samuel Wyllys Papers, Brown University Archival and Manuscript Collections.*

Their final points tackled whether fortunetelling or "discerning secrets" about the future was an unquestionable sign of association with the devil:

> *Those things, whither past, present or to come, which are indeed secret, that is cannot be known by human skill in arts or strength of reason arguing from the course of nature or…by divine revelation…nor by information from man must needs be known (if at all) by information from ye Devil…the person pretending the certain knowledge of them seems to us to argue familiarity with ye Devil.*

Predicting the future was indeed a sign of diabolical involvement, the panel said. Yet as many historians have written, these changes, coupled with opinions formed over Katherine Harrison's case, in many ways marked the

beginning of the end of Connecticut's witch trials. For Katherine, they also meant she would not face the noose.

Similar to what occurred at the end of the Elizabeth Seager trial, Generall Court magistrates in May 1670 called a special session of the Court of Assistants to meet in Hartford and, with Deputy Governor William Leete presiding, issued the final decision on Katherine's sentencing:

> *This Special Court having considered the verdict of the jury respecting Katherine Harrison cannot concur with them so as to sentence her to death or to longer continuence in restraint do dismiss her from her imprisonment, she paying her just fees. Willing her to mind the fulfillment of removing from Wethersfield which is that which people will be the most to her own safety and contentment of the people who are her neighbors.*

CHAPTER 7
Wicked Democracy

Government and Gallows in Connecticut

You do swear by the Great and dreadful name of the Everliving God that you will duely and truly try the case given you in charge twixt the Commonwealth and the prisoner at the bar according to the evidences given in open court to prove the charge laid against her. And, when you are agreed on a verdict, you shall keep it secret until you deliver it in open court. So help you God.
—Connecticut Colony Grand Jury oath

Interpreting past events through contemporary attitudes is a practice called "presentism" that, according to many historians, leads to a distorted understanding of why and how those events occur. It's often used as a tool to validate or condemn current beliefs, but it should never be seen as an accurate lens to validate or condemn historic ones.

"Today, we want to make Connecticut's witch hunt cases a very simple and crystal-clear case of injustice, but it's not that simple," said Connecticut state historian Walter Woodward. "New England's witch hunts came out of very real fears, and what were very real beliefs, that the devil and witches were threats to [people's] lives, livelihoods, communities and eternal souls. That's very different to how we see witches now."

Colonial laws and attitudes were also very different from those that exist today, said Yale University history graduate student David Brown in a 1992 article. Published by the *New York Times* to highlight celebrations planned to mark the 300th anniversary of the Fairfield Witch Panic, the article "When Courts Grappled with the Devil" features Brown arguing that

A centuries-old engraving called *The Four Witches* by German master Albrecht Dürer. In the left corner is a small portal showing a demon's face engulfed in flames, suggesting an entrance to hell.

given Connecticut's beliefs in the 1600s, those accused of witchcraft were justly prosecuted. Unlike during the Salem trials, where chaos reigned and many legal protocols were pushed aside, Connecticut magistrates carefully followed colony laws and procedures, which were based on those established in England and the Massachusetts Bay Colony. The formal judicial process for witchcraft cases included:

- Filing an official complaint with local magistrates.
- Prosecutors interviewing witnesses, examining the accused for witches' teats and collecting other needed evidence.
- Sending all gathered information to Hartford's "Generall Court," which tried capital cases, for review.
- Generall Court magistrates determining whether enough evidence existed for a witchcraft trial and, if it did, sending the prosecution's case to a grand jury for indictment.
- If indicted, having the accused be formally tried by a jury. In most instances, the governor's assistant served as the main prosecutor. The prosecutor and the accused called witnesses, though it's unclear whether the accused were represented by an attorney or represented themselves. Once all the evidence was presented, the jury delivered its verdict and the governor imposed a sentence. If the jury returned a verdict with which the head magistrate disagreed, he could overturn it.

Although Old Testament scripture served as the foundation for colony laws and practices, these protocols were not, at the time, considered old-fashioned. Priding themselves on having open and progressive mindsets, Puritan leaders involved in lawmaking scrapped longtime practices they felt were cruel, inappropriate or outdated, including those related to witchcraft. Traditional interrogation techniques, such as burning accused witches with red-hot irons or scalding them with boiling water, were discarded for being "insufficient." Only those practices considered effective were written into Connecticut's new law books. Though when it came to witchcraft, the water test was controversial in the young colony.

Puritan zealot Increase Mather dismissed the idea that a person in line with the devil would be rejected from water: "All water is not the water of baptism," he wrote in *Essay for the Recording of Illustrious Providences*, "only that which is used in the very act of baptism…The bodies of witches have not lost their natural properties; they have weight in them as much as others.

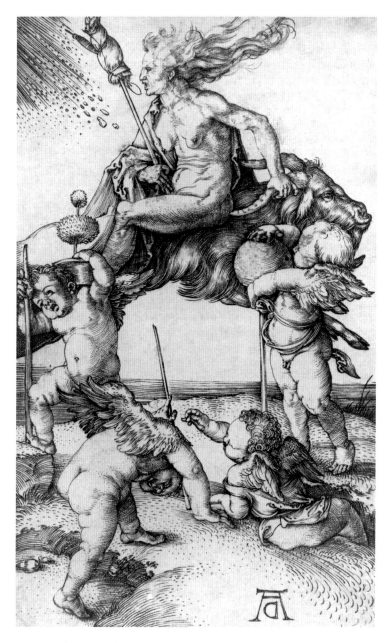

Another of Albrecht Dürer's engravings, *Witch Riding Backward on a Goat Accompanied by Four Putti*, 1505. *Library of Congress Prints and Photographs Division.*

Moral changes and viciousness of mind make no alteration as to these natural properties, which are inseparable from the body."

Records also show how seriously magistrates considered their responsibilities. Judges, prosecutors and the accused were all required to adhere to strict practices, with only the presentation of "just and sufficient" evidence leading to a guilty verdict. Witchcraft cases, however, presented unique challenges. Prior to 1662, just a single witness was needed to support a witchcraft conviction. After that, Connecticut required simultaneous witnessing of the same incident by two or more people, primarily thanks to the efforts of Governor John Winthrop Jr., who aggressively encouraged skepticism and greater moderation in dealing with witchcraft accusations. He also successfully lobbied to dismiss the use of spectral evidence—claims of ghosts and spirits that only the person being attacked or afflicted by these specters could see—which, significantly, moved the burden of proof in witchcraft cases from the defendant to the accuser.

According to the "Grounds for Examination of a Witch" found in the Samuel Wyllys Papers, "ye truer proofs, sufficient for conviction," include the following:

> *Ye voluntary confession of ye party suspected; adjudged sufficient proof by both divines and lawyers. Or second the testimony of two witnesses of good and honest report avouching things in their knowledge before ye magistrate: first whether that party accused hath made a league with ye devil or second hath been some known practices of witchcraft. Arguments to prove either must be as:*
>
> *If they can prove ye party that invocated ye devil for his help through a pact that ye devil binds witches to.*
>
> *Or, if ye party hath entertained a familiar spirit in form of mouse, cat or other visible creature.*
>
> *Or, if they affirm upon oath ye party hath done any action or work which infers a pact with ye devil, as to show the face of a man in a glass, or used enchantments or such feats, divining of things to come, raising tempests, or causing ye form of a dead man to appear or ye like; it sufficient proves a witch.*

In addition to ensuring that all legal requirements were met, magistrates and other leaders overseeing witchcraft cases had to manage public outcries and opinions. As author and historian Richard Godbeer explains in *Escaping Salem: The Other Witch Hunt of 1692*:

The grave of Connecticut physician and alchemist Gershom Bulkeley in Wethersfield Village Cemetery. Bulkeley played a key role in leading Governor John Winthrop's efforts to redefine "diabolical magic" and reform evidence needed for a witchcraft conviction.

Few ordinary folk appreciated the rigorous standards of proof that judges were bound to uphold: they often considered the evidence presented in court to be clearly damning and felt betrayed if the accused was acquitted...Magistrates wanted New Englanders to believe that courts charged with witchcraft cases took seriously the testimony that accusers submitted, even though that testimony could

not always support a conviction. At the close of [a] trial, the judges advised the defendant "solemnly to reflect upon the case and grounds of suspicion given in and alleged against her," and told her that "if further grounds of suspicion appear against her by reason of mischief done to the bodies or estate of any by any preternatural acts proved against her, she might justly fear and expect to be brought to her trial for it."

Although no Connecticut leader involved in the witch trials played a role as important or impactful as Governor John Winthrop Jr., as explained in Chapter 6, other noteworthy officials who particularly deserve recognition include:

REVEREND GERSHOM BULKELEY: Vocal and eloquent, this Glastonbury resident used his writing abilities to both help secure a pardon for Mercy Disborough during the Fairfield Witch Panic and put an end to Connecticut's witch trials overall. During the witchcraft trial of Katherine Harrison, Bulkeley asserted it was "invalid" to accept specter evidence from just one witness, as well as that God would not allow the devil to take the shape of an innocent person because it "would evacuate all human testimony; no man could testify that he saw this person do this or that thing, for it might be said that it was ye devil in his shape." He also used the witchcraft conviction of Mercy Disborough to illustrate the need for a new Connecticut charter and how its residents could be subjected to what he viewed as an arbitrary enforcement of laws. After his death in 1713, an obituary in the *Boston News Letter* included this description: "Eminent for his great parts, both natural and acquired, being universally acknowledged, besides his good religion and virtue to be a good person of great penetration and a sound judgment, as well in divinity as politics and physic, having served his country many years successfully as a Minister, Judge, and a Physician with great Honor to himself and advantage to others." Interestingly, Bulkeley did not believe in the existence of witches.

ROGER LUDLOW: One of the founders of the Connecticut, Fairfield and Norwalk Colonies, Ludlow crafted Connecticut's first code of laws and its Fundamental Orders, which historians call the first democratic constitution ever written. Modeling Connecticut's capital laws after English laws and those adopted by the Massachusetts Bay Colony, he drafted the explanation of how and when a person could be legally accused of witchcraft, among other capital offenses, which was adopted by the Connecticut General Assembly. Elected Connecticut's first deputy governor in 1639, Ludlow in 1653 was involved in a slander suit after saying Mary Staples of Fairfield

was a witch and "makes a trade of lying." Preparing to leave for a trip to England and not wanting to lose the time it would take to attend the Staples defamation trial, Ludlow gathered written depositions in his defense and sent them to court with his attorney. Judges refused to accept the evidence, saying the testimonies couldn't be verified. Because of this, the Stapleses, who did testify in person, won the suit. Soon after, Ludlow left Connecticut, traveling first to Virginia and then to England. Although "marred by defects of temperament" and "inclined to arrogance," said genealogist Donald Lines Jacobus in *The History and Genealogy of the Families of Old Fairfield*, Ludlow has earned an "enduring place in history…and his work in the field of jurisprudence, which was able, sound, and as liberal as could be expected for the era." It also created the frame that held and shaped Connecticut's witch trials.

All convicted witches in Connecticut died by the hangman's noose.

DR. BRYAN ROSSITER: A Guilford physician and one of the founders of the Windsor Colony, Rossiter in 1662 performed the first complete autopsy in Connecticut, as well as the first autopsy in colonial America performed as part of a witch trial. Unfortunately, he did not have the medical expertise needed to show that disease, rather than witchcraft, was the cause of young Elizabeth Kelley's death. However, just the fact that he was called in to consult is significant, said Connecticut witch trials scholar R.G. Tomlinson in *Witchcraft Prosecution: Chasing the Devil in Connecticut*, as it illustrates that

even in the midst of the Hartford Witch Panic, mindsets were beginning to change:

> *It cannot be overemphasized what a key moment this was and is in Connecticut history. Among a population that did not routinely question supernatural forces, a doctor was being asked to determine, by scientific examination, whether the girl's death had been from natural or unnatural causes. The mere fact that the question could be raised represents a divide between pure superstition and the rule of reason.*

REVEREND SAMUEL STONE: One of the founders of Hartford, Stone took over as minister of the colony's appropriately named First Church after its founder Reverend Thomas Hooker died. An aggressive witch prosecutor, he also showed that although Puritans left England to obtain freedom of religion, most did not tolerate any beliefs but their own. Unpopular with both parishioners and church elders for, among other things, his belief that the ministry should be "a speaking aristocracy in the face of a silent democracy," Stone was an eager participant in Connecticut's witch trials, particularly the Hartford Witch Panic. He spent much of his time recording the testimonies of those allegedly bewitched. According to Tomlinson, he "immersed himself in obtaining a statement of repentance from Mary Johnson prior to her execution" and, for this and similar efforts, was described as "the famous Mr. Samuel Stone" by Cotton Mather.

SAMUEL WYLLYS: Evolving from what Tomlinson called a "witch prosecutor to an active protector," Wyllys was an elected official in the Connecticut Colony for close to forty years, standing in as head of the Generall Court when the governor or deputy governor was absent, as well as serving as a commissioner of the United Colonies. His father, Samuel Wyllys, was elected governor of Connecticut in 1642, and like John Winthrop Jr., Samuel Wyllys was unconvinced that all unexplainable occurrences were caused by the devil. An active supporter of Winthrop's efforts to change witchcraft laws and beliefs, he played a key role in securing Mercy Disborough's reprieve and pardon. A meticulous record keeper, Wyllys is responsible for the majority of surviving court documents and depositions from Connecticut's witch trials, which are split between archives at the Connecticut State Library and Brown University.

CHAPTER 8
The Wallingford Witch

Connecticut's Final Witchcraft Trial

The Court…[advised] Winifred Benham solemnly to Reflect upon ye case and grounds of suspicion given in and alleged against her. And told her if further grounds of suspicion of witchcraft or further evidences should appeare against her by Reason of Mischief don to ye bodyes or estate…she might justly feare and exspect to be brought to her tryall for it.
—from November 2, 1692 hearing in New Haven Colony County Court

In many ways, Salem's witch trials might have played as significant a role in changing Connecticut's colonists' minds about witchcraft as John Winthrop's or Reverend Bulkeley's urgings. Historians have recorded Connecticut residents describing the craze and pitch of Salem's witch hysteria as a "miserable toil" and "great noise." They read and listened to news of happenings in the "quarrelsome" village with as much skepticism as interest. This new attitude could have only benefited Wallingford's Winifred Benham and her thirteen-year-old daughter, who, in 1697, were accused of using witchcraft to "misteriously [hurt] the Bodies and Goods" of several children.

The trial marked the third time mother Winifred King Benham had appeared in court for witchcraft. Some histories identify Winifred was the daughter of Mary Hale, a Boston woman accused and acquitted of witchcraft in 1668. But whether this is true is more interesting than influential. The first accusations against Winifred came in 1692—the same year as Salem's trials—from neighbor Goody Parker, who, after Winifred's

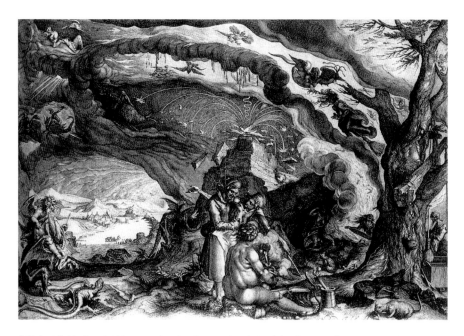

Witches' Sabbath, a 1610 engraving by Amsterdam's Andries Jacobsz Stock, currently housed at Rijksmuseum—The Museum of the Netherlands.

case was dismissed, sought the "anxious solitude" of the Reverend Street, who then asked magistrates to reconsider Goody Parker's claims of "many pecular things" about Winifred Benham.

Winifred's husband, Joseph, responded to the claims by telling Goody Parker that if she made any more accusations, he'd load his gun with two bullets and use both of them on her. The threat required both Joseph and Winifred to appear in New Haven County Court, but no charges were formally filed on the grounds of insufficient evidence. However, Goody Parker's claims, and Joseph's actions, were enough to cast a shadow on Winifred. Rumors about her persisted, and the following year, she was in court again on witchcraft charges.

Like the first time, the charges were dropped, and Winifred was released, this time accompanied by a warning that if "further evidences should appear," she should "feare and exspect to be brought" to trial. Joseph was also required to post twenty pounds bond and promise that he'd ensure her good behavior.

Frustrated and alarmed—and no doubt prodded by Goody Parker—Reverend Street excommunicated Winifred, though the exact timing of this

action is uncertain. Author George Munson Curits considered Winifred and Joseph's state of mind in his *Early History*:

> *Presumably Joseph and Winifred breathed more freely…as they thought of the peril she had escaped. But her life in Wallingford could not have been pleasant thereafter. Her neighbors looked at her askance, and every act and word must have been scanned and twisted to suit the desires of those who sincerely believed she spent her nights riding on a broomstick in company with the devil. They had a daughter, Winifred, who must have shared much of the unhappiness of her mother's life. This strained situation continued for five years with no outbreak.*

Perhaps the Benhams were unkind or untidy neighbors, for their actions continued to be watched and scrutinized. They remained under suspicion of wrongdoing and, in August 1697, both Winifred and her teen daughter—also named Winifred—were charged with using witchcraft to afflict three children of prominent Wallingford families: Sarah Clark, sixteen; Elizabeth Lathrop, nineteen; and John Moss, fifteen. The two Winifreds were also accused of causing the death of a young child through the "appearance of spots."

After "strict examination" of the "sufficient ground of suspicion," New Haven County Court magistrates ruled the women should be tried as a capital case in Hartford. Joseph Benham paid the forty-pound bond needed to keep his wife and daughter out of jail for the two months that would pass before they appeared before the Generall Court of Assistants.

CONNECTICUT'S FINAL WITCH TRIAL BEGINS

No transcripts of the Benhams' witchcraft trial exist. Yet in a December 1999 issue of the *Record-Journal* newspaper, staff writer Jeffery Kurz presented "an account, with certain Embellishments, of the Trial of the Benhams." Titled "The Wallingford Witch Project," the piece was the daily's lead story at the top of page one and, after jumping inside, takes up all seventeen by twenty-two inches of the broadsheet page.

Even when the newspaper industry was booming, it was an enormous amount of space to give to a single story. But given that this one states from the get-go that it's not all true—it's "based on records available and with

some fictional license to fill in the blanks," Kurz said—the fact that it was given such play is puzzling. Clearly, much of the story came from Kurz's imagination, though the details he includes show extensive research was performed. The piece also does an effective job conjuring how it might have felt to be within that 1697 courtroom:

> *Goodwife Hannah Parker is the first to speak. She stands before the judges and begins in slow, careful tones. But it is not long before her voice rises, as if carried away by the heat of passion.*
>
> *It was to her house, she says, that the children first came. Hysterical, the girls with tears in their eyes, tearing at their own clothes as though they were trying to scratch an affliction from their bodies. She tried to calm them down, says Goody Parker. But it took a long time. The girls were so frightened. When they spoke, it was in unison, as though they were controlled by one mind.*
>
> *"And what about the young master?" asks Governor Jones.*
>
> *"He was frightened too," says Good Parker. "Who wouldn't be? But he's a quieter sort, a thoughtful one. It was he who told me about the baby."*
>
> *"What baby?" asks the governor.*
>
> *"The Royce child, the one who died last year."*
>
> *"He had the spots too, the same as them," says one of the girls, Sarah Clark.*
>
> *"Quiet child. You may speak when you are asked."*
>
> *"The baby had the spots," Goody Parker tells the governor. "Same as them." She points to the Benhams, mother and daughter, who sit across the divide with scant expressions. They stare straight ahead, keeping their eyes from their accusers. They know any reaction will be open to interpretation, and that there is no way to tell whether it will be favorable or not. Earlier, in Connecticut, not too far from here, a woman had been hanged for saying no more than that she did not believe in witches. Next to the girl, young Winnifred, is her father, who obviously shares no such sense of restriction. His face as red as a tomato in the sun, he repeatedly stamps the heel of his boot onto the hard wood floor waiting.*
>
> *"Where were these spots?" asks the honorable governor.*
>
> *"On the bodies of these two," says Goody Parker, her voice rising.*
>
> *"No," he says. "I mean, where did you see them?"*
>
> *"I didn't see them," Goody Parker says. "The children did."*
>
> *He turns to Sarah Clark, the one who had spoken up before. "And where did you see them child?"*

"At night. She came into my room." The girl's voice trembles. "I thought it was impossible. But she was there. She showed me the spots. On her arms…"

The girl moves to the center of the room and points to the rafters, a look of terror on her face. "They were…in the air, suspended in a way that I didn't understand…how could anyone do that?"

Some witnesses later said that at this they felt the odor of burning leaves enter the room, even though it was still summer and no leaves had yet fallen. This was attributed to the presence of the Devil in the courtroom that day.

"It was Satan," Goody Parker says. "Satan who had sent them to you! Satan on whose behalf they came to gather you up."

A voice rises like thunder from the other side of the room. "By God, I've had enough of this!"

It's Joseph Benham, his voice shaking with fury.

"You will sit down sir!" roars the governor. "You will wait your turn, or I will have you removed from this court room."

"These children are obviously being led," says Benham. "Can't you see that?"

"What I can see is a man who will find himself in irons. Your temper has cost you before. You are well advised to find a way of controlling it now."

As Benahm sits, the governor addresses the children. "You know these are serious charges, that people have hanged for being in the control of the Devil. You know this, every one of you?"

The children stare at him. "I want you to speak. I want you to swear that what this girl, Sarah Clark, says is the truth, that each of you in the night have been visited by Goody Benham and young Winnifred Benham, or their apparitions on behalf of the Devil, and that you were afflicted with the mark of the Devil, that same marks being on them…"

"…but going away."

"Going away," says the girl. "The spots quickly vanishing. On the baby. The spots were there and then they were gone."

"The spots quickly vanishing. Do you swear this is the truth?"

The children, one by one, softly, like a whisper, say yes. "Yes." "Yes." "Yes."

The governor turns his head to the other side of the courtroom. "Now Goody Benham, what have you to say to these stories? Can you answer these accusations?"

How Winifred responded to these or any of the witchcraft accusations made against her is unknown. Like so many documents lost from the period,

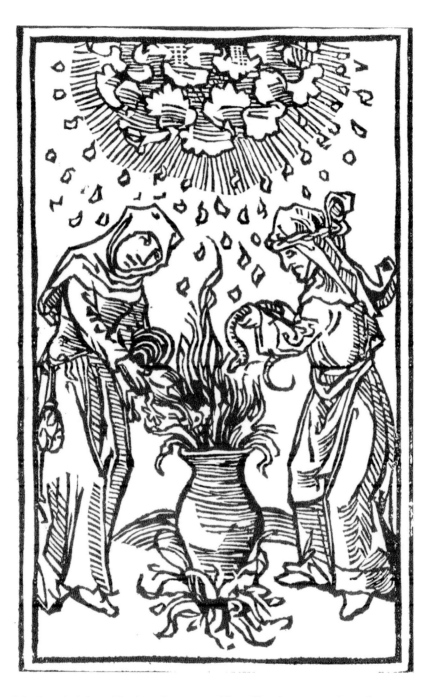

Woodcut of witches adding ingredients to a cauldron, fifteenth century, author unknown.

the records do not exist. What is known is that as part of prosecutors' investigations, Winifred Sr. was searched for witch teats and underwent the water test. But apparently, if any evidence was found, it was deemed insufficient. According to the Records Court of Assistants, jury members returned the decision of "ignoramus," meaning "we are ignorant of" or "not proven," and dismissed the case.

The witchcraft trial of Winifred and Winifred Benham was the last to ever take place in Connecticut. In 1713, Bethiah Taylor of Colchester accused two of her neighbors—Sarah Clother and the wife of Thomas Brown, whose first name is unknown—of being witches. In 1724, Elizabeth Ackley of Haddam accused her sister-in-law Sarah Spencer of Colchester of "riding," "pinching" and bewitching her. Elizabeth was married to Sarah's brother James, who responded to the claim by threatening to harm his wife. Enraged, Sarah sued Elizabeth for £500 and presented the court with a certificate from her minister that vouched for her faith, piety and virtue.

Magistrates dismissed Elizabeth's claim but ordered her to pay Sarah five pounds in damages plus all court costs. The Ackleys appealed, and Elizabeth pleaded insanity. The court, however, rejected the appeal, ruled that Elizabeth was not insane and stated that she was guilty of slander.

When the Connecticut Colony's Generall Court released its updated list of "Capitall Lawes" in 1715, witchcraft was still listed as the number two offense. When capital offenses were next printed in 1750, the witchcraft law was gone. No legislative records show any kind of discussion or vote taking place. Judicial documents give no mention of the decision. Like magic, the law that led to panics, fear and the death of eleven Connecticut residents just silently disappeared.

CHAPTER 9
Bewitched

Myths and Mistruths About Connecticut's Witch Trials

For conviction, it must be grounded on just and sufficient proofs. The proofs for conviction are of two sorts. Some be less sufficient, some more sufficient. Less sufficient, used in former ages, by red hot iron and scalding water. Ye party to put in his hand in one or take up the other. If hurt, to be convicted for a witch. If not hurt, ye party cleared, but this as utterly condemned…Another insufficient testimony of a witch is ye testimony of a wizard…he [is] diabolical and dangerous, ye devil may represent a person innocent.
—*excerpt from the* Connecticut Colony's Grounds for Examination of a Witch

Of course, the greatest mistruth about Connecticut's witch trials is that none ever occurred, or that the Salem trials came first, or that the Salem witch trials were the only or most heinous in New England. But even among those aware that Connecticut experienced its own witch panic, there are many mistruths. The fact that so few documents exist from the time period only causes the line between reality and myth to blur that much more.

Most myths and legends are based in history. But as journalist Heather Whipps explains on the LiveScience website, they also offer insight into our fears, attempt to explain things we don't understand and, maybe most importantly, can be great fun. "Life is so much more interesting with monsters in it," University of Wales folklorist Mikel J. Koven told her.

Like many academics, Koven said he believes most myths and legends are at least partly based on truth. But problems occur when fictional stories start being taken as fact.

Searching seventeenth-century gravestones will lead to many that are engraved with a winged skull, symbolizing the ascension into heaven. However, under none of these stones will be the bodies of convicted witches. Connecticut residents executed for witchcraft were buried in unmarked graves. Their locations are unknown.

Hartford's Trinity College in 1909. Many believe convicted witches were hanged at Trinity's Gallows Hill. However, the only proven executions to occur there were of a handful of British Loyalists during the Revolutionary War.

An 1881 issue of a monthly magazine called *Frank Leslie's Popular Monthly* can be credited with perpetuating—or perhaps even creating—at least one false, though entertaining, story about a supposedly hanged witch named Juliana Cox from Glastonbury. According to the *Popular Monthly* article, a clipping from an 1823 *Hartford Times* was found in the scrapbook of a Glastonbury resident about Juliana, who in 1753 "was one of the few who

were hanged in Connecticut." Her death was part of the "witch business" begun "before Massachusetts," said *Popular Monthly* editors, who wrapped their article around an illustration of a frightened Puritan woman cowering on the ground as a dog bites her shoulder and a man, pointing and yelling, arrives with a musket.

The article goes on to say Juliana Cox was executed on "Gallows Hill in Hartford…now known as the commanding trap-rock ridge by the stone-pits." Likely referring to the steep stone cliff near the corner of Vernon and Summit Streets across from what's now Trinity College's St. Anthony Hall, this particular spot has for decades been wrongly identified as a location where witches were hanged, though a clarification is needed.

Gallows did once stand at Trinity College's Gallows Hill, but not during Connecticut's witch panic. One hundred years later, during the Revolutionary War, the Patriot army hanged three or four British Loyalists there—but no witches, just like there was likely no Juliana Cox.

"I feel pretty confident saying that if a witch lived in Glastonbury, and was executed as late as 1753, we'd have some kind of evidence," said James Bennett, director of the Historical Society of Glastonbury. "Record-keeping in the mid-eighteenth century was much better than a century before" when the majority of Connecticut's convicted witches were hanged.

Library and Internet searches for the *Hartford Times* article that *Popular Monthly* cites also lead to nothing. But even if the *Popular Monthly* article was meant to be a joke, it's easy to see why many might have taken it as truth. Names, dates, times and places are written as if they were gospel, and descriptions of Juliana's words and actions are similar to those that occurred at several actual trials and hangings. The piece is also written with journalistic authority, with details that go as far as listing the names of official "committee members" charged with examining Juliana for witch marks. Here is the article:

In the beautiful town of Glastonbury, in Connecticut, the following remarkable event occurred in 1753: In March of that year, one Julius Perry went out with his dogs to hunt. In the depths of the forest, he discovered (as he alleged) an old gray fox, and his dogs gave chase. After chasing this fox upward of two miles, the animal was holed. When Mr. Perry came up, he heard a strange noise over the other side of the hole, and going to the spot, he found Juliana Cox lying and panting for breath. Her left shoulder was bleeding, and had on it the marks of the dog's teeth. This was just the spot on the gray fox's shoulder where the dogs had seized hold. Upon this

testimony, Miss Cox, a maiden lady of forty-four, was brought to trial for the capital offense of being a witch. On her arraignment, she pleaded not guilty, and it was determined that a committee of selectmen should examine her person for witchmarks, in order to introduce confirmatory proofs against her. She was, therefore, remanded to prison.

The following persons were appointed on the committee: Eben Brewer, Alexis Jones, and Samuel Cutworth. These men proceeded at once to the prison, and stripping Miss Cox, they began their examination. For a time, exceeding an hour, they could find no marks, and Miss Cox submitted to their examination with tears and sobs. Finally, when they had pricked many places on her body without success, she confessed to two marks—one a little below the right hip and one on the left arm. The committee now became satisfied that there were true marks, as the flesh was thereon discolored in a slight degree. They thereupon made their report to the court appointed to hear the trial.

This evidence, confirming that of Mr. Perry, was thought to be conclusive, and on the 3ᵈ of April the trial took place. It was thought unnecessary to resort to further tests, and Miss Cox was found guilty of witchcraft on the evidence already quoted, and sentenced to be hanged. Strange noises and demons haunted the jail at Hartford up to the time that her execution took place, which was on the 7ᵗʰ of April, at five o'clock in the morning.

There was a large concourse of men and women attending her execution, and, although she declared that she was unjustly accused and that she confessed to the witchmarks to stop the pain of being so cruelly pricked by the committeemen, yet every person present believed her to be a true witch, and in league with the devil. She further declared that Julius Perry accused her wrongfully. She said she was in the forest gathering herbs, and that Julius Perry came along and would have his will of her; that, she constantly refusing, he set his dog upon her, and the animal bit her shoulder; and that he, fearing to be detected in this bad act, had laid the charge of witchcraft against her. This she said under the gallows. Whereupon a shout was made among the people to "burn the witch!" as hanging was way too easy a death for so foul a strumpet of the devil. While the people went to fetch wood to burn her, the sheriff hung her up, so that she died on the gallows before the wood could be brought.

The story of Julius Perry and Juliana Cox is convincing and entertaining but entirely untrue. But thanks to the fact that all of *Popular Monthly*'s nineteenth-century issues exist online in digital form, it exists in perpetuity

The Newbery Medal–winning children's novel *The Witch of Blackbird Pond* by Elizabeth George Speare is based on accused witches from Wethersfield. Published in 1958, it's still part of many school curriculums. *Houghton Mifflin Company.*

for anyone to find, believe and share with others. And it's not the only lasting source of mistruth.

As journalist Chris Pagliuco said in a 2007 article in the *Hog River Journal* (now *Connecticut Explored Magazine*), it's ironic that one of the most prominent sources of information about Connecticut's witchcraft history is also the source of much misinformation. His comment refers to the much-beloved 1959 Newbery Medal–winning novel *The Witch of Blackbird Pond*, which for decades has been required reading for middle-schoolers around the country.

Written by Massachusetts author Elizabeth George Speare (who in 1962 won another Newbery for her children's novel *The Bronze Bow*), the book tells the story of orphan Kit Tyler, who, after her grandfather dies, travels by ship from her home in Barbados to live with her Aunt Rachel and Uncle Matthew in Connecticut's Wethersfield Colony. The only place she feels free in this strict, Puritan community are the meadows, where she makes friends with an old Quaker woman known as the Witch of Blackbird Pond. When Kit's friendship with the "witch" is discovered, Kit is accused of witchcraft.

Comparing fiction with fact, the latter occurrence makes much sense. Being a "companion...of a known or convicted witch" was one of the colony's "Grounds for the Examination of a Witch" and often came into play. Other details and circumstances, however, don't add up to reality, said Wethersfield Historical Society volunteer Martha Smart, who for fourteen years worked at the Connecticut Historical Society as a reference librarian.

"Although it happens in the book, no one accused of witchcraft in Wethersfield was actually tried in Wethersfield," said Smart, who several times a year leads historical tours of downtown Wethersfield that include a stop at the Buttolph-Williams House on Broad Street, which is featured in the novel. She and other docents there also tell the story of Mary Johnson, the Wethersfield woman and first colonist to admit to witchcraft, who is the focus of Chapter 3.

Smart continued:

> *Unlike the "witch" in* The Witch of Blackbird Pond, *no woman in any Puritan community would be allowed to live alone, even if she were considered strange or an outcast. Married women were required to live with their husbands, and unmarried women to live with family members. Also, Quakers and Puritans did not mix. They lived in separate communities. But even though Puritans saw Quakers as dissidents, they would not persecute them as witches on religion alone. Remember that the Puritans left*

Old women are frequently portrayed as crones or witches—even in young children's books. This Victorian-era image, whose artist is unknown, is believed to have accompanied a little-known Mother Goose nursery rhyme that goes like this: "There was an old woman tossed in a basket/Seventeen times as high as the moon;/But where she was going no mortal could tell,/For under her arm she carried a broom."

England for religious freedom, so even though they did not agree with the Quakers, they certainly did not attack them. Blackbird Pond is a great story, but it needs to be treated as such—as a story. It doesn't portray the truth of Connecticut's struggles with witches, though it can be used to teach tolerance and the need to be more accepting of those who are different.

Also important is the fact that *The Witch of Blackbird Pond* is set in 1687: the last year of what state historian Walter Woodward called "a quarter-century of silence where witch hysteria faded and not a single witchcraft execution occurred."

To combat these and other myths—especially those that have to do with broomsticks and pointed hats—Lisa Johnson from Farmington's Stanley-Whitman House urges research, particularly related to individuals affected by the witch trials. "We know that on the state level, documents don't exist anymore. That makes research on individual people critical. I'm sure that hidden in boxes and attics and cellars are letters and diaries that can give us details about at least that particular person involved. And the more we known about each individual person, the better we will be able to put together the overall story."

So what fanciful facts about Connecticut's witch trials are true? Sir Winston Churchill, former English prime minister and one of the most significant world leaders during World War II, is a descendent of Mary Staples of Fairfield. Mary was accused of witchcraft in 1654, exonerated and may have been charged again in 1692, though records are inconclusive.

Lexicographer and textbook creator Noah Webster, whose name in the United States has become synonymous with "dictionary," is a descendant of Lydia Gilbert of Windsor, who was tried and hanged in 1654.

Descendants Petition for Posthumous Pardons

WHEREAS, in colonial Connecticut, various men and women were accused by their neighbors and townsfolk of practicing witchcraft; and…

WHEREAS, such accusations were sometimes made because a person was associated with the sudden and unexplained illness of another person, or predicted the illness or recovery from illness of another person, or had knowledge of past or future events; and

WHEREAS, such accusations were sometimes made simply because a person habitually muttered to himself or herself, or talked to unseen persons, or used vulgar language, or gave evil looks, or was a notorious liar, or was a nonconformist, or caused discord among his or her neighbors; and

WHEREAS, some of the accused persons were indicted and put on trial for practicing witchcraft; and

WHEREAS, these trials were conducted without the evidentiary procedures and safeguards that are standard in Connecticut's criminal justice system today; and

WHEREAS, some of the accused persons were found guilty of practicing witchcraft and sentenced to death by hanging.

NOW, THEREFORE, BE IT RESOLVED, that although the facts of the accusations, prosecutions, trials and executions of persons practicing witchcraft in colonial Connecticut cannot be undone or changed, the General Assembly declares its belief that such proceedings, even if lawful under the existing law of the Colony of Connecticut, were shocking, and the result of community-wide hysteria and fear, and that no disgrace or cause for distress should attach to the descendants of these accused and convicted persons...

Almost four centuries after the first person in Connecticut was executed for witchcraft, descendants of the eleven sentenced to death lobbied the state General Assembly to pass a joint resolution condemning the trials and exonerating those convicted, even though the acts were lawful at the time they took place. The 2008 legislation was introduced by State Senator Andrew Roraback of Goshen at the request of mother and daughter Debra and Addie Avery, whose great-great-great-great-great-great-great-great-grandmother (one more great for Addie) was Mary Stanford of Hartford, convicted and hanged in 1662.

"Mary Stanford is our grandmother. It doesn't matter if she's eight generations back," Debra told the *Hartford Courant.*

Mary's husband, Andrew, also charged, was set free when the jury couldn't reach a verdict. But Mary went to the gallows. The few court records that survive show that at the time of Mary's death, they were the parents of four or five children, the oldest at least sixteen years old and the youngest six.

Charges against Mary were "familiarity with Satan" and having "acted and also come to the knowledge of secrets in a preternatural way beyond the course of nature to the great disturbance of several members of this Commonwealth."

At the trial of fellow Hartford resident Rebecca Greensmith the following year, Rebecca would also name Mary as one of several witches who met in the woods for diabolical bacchanals. Rebecca was also hanged. Debra Avery spoke out on behalf of Mary, Andrew and the other accused at the March 2008 legislative hearing for the bill:

Why exonerate our citizens wrongly accused so many years ago? Though the governing body of colonial times in Connecticut believed they were protecting their community members by prosecuting those suspected of practicing witchcraft, today we recognize that those convictions were unfounded and acknowledgement of their innocence through a formal resolution will serve to correct the official record, as well as educate the public on the dangers of judicial scapegoating. Mob rule has left its ugly mark many times during

"I am no witch. I am innocent. I know nothing of it," said Bridget Bishop, the first person executed for witchcraft in Salem, before she was hanged. No known record exists of the last words of Alse Youngs, who fifty years earlier in Hartford was the first person to be executed for witchcraft in New England.

social unrest in America, from colonial witch hunts to the lynchings in the segregated south. The term witch hunt is still used today when we perceive an unjust search for the truth.

Other descendants expressed similar sentiments, including Patricia Borris, whose great-great-great-great-great-great-great-great-great-great-grandparents Joan and John Carrington of Wethersfield were both indicted for "familiarity with Satan" and "works above the course of nature" and hanged in 1651. Aside from records that show the Carringtons' estate was worth no

more than twenty-four pounds, these meager facts are all that's known about the couple. Equally slim, but powerful, were the words Borris said to legislators considering the exoneration resolution: "It is never too late to right a wrong."

At the time, many legislators touted the exoneration measure, including state representative Michael Lawlor of East Haven, who, during the committee hearing, told descendants: "This is really a fascinating story and a piece of Connecticut's history—a shameful piece. As much as this is about clearing the names of your families, it's really clearing the name of our state and its history, and acknowledging that what happened was such a tragedy and an outrage." Unfortunately, to the dismay of those who worked so hard for it, Senate Joint Resolution No. 26 never made it out of the Judiciary Committee. Legislators failed to vote on it before the session ended, and efforts to revive it in 2009 failed.

Other states, however, have made restitutions for witch convictions, even if just symbolic ones. In 1957 and 2001, Massachusetts issued pardons for several of those convicted in the Salem trials. The actions were follow-ups to a decision in 1711 to exonerate all those accused and offer compensation to their relatives for the unlawful ways confessions and testimonies were obtained.

In 1711, just nineteen years after the Salem hysteria, only a handful of families came forward to accept the apology. Shame and mistruths about the accused villagers still existed, as did relatives' fears about admitting their connection to an accused or convicted witch. By the late twentieth and early twenty-first centuries, this mindset had thankfully changed, and several Massachusetts descendants came forward, asking that pardons and apologies be offered again.

Legislators in Virginia and New Hampshire have also provided exonerations for seventeenth-century residents accused and executed for witchcraft in those colonies. But if past results are any indication, the apologies and "justice" Connecticut witch trials descendants want for their ancestors may not arrive.

Requests to Connecticut's Board of Pardons and Paroles have been denied, its bylaws stating it does not grant posthumous pardons. Additionally, today's state government has no jurisdiction over colonial Connecticut, officials said. In response to this, one descendant wrote a letter to England's Queen Elizabeth II, hoping that because colonial Connecticut was under English rule during its witch trials, she or Parliament would grant posthumous pardons. But that request was also denied.

Revitalized efforts in 2012 led to descendants asking Connecticut governor Dannel P. Malloy to issue not a pardon but a proclamation that

One of the Connecticut Colony's seals. It's believed that the three grapevines represent the colony's first three communities, where the earliest witch accusations occurred. The Latin "Qui Transtulit Sustinet" translates into "he who is transplanted sustains" and is still the state's motto today.

would clear their relatives' names and condemn the prosecutions and killings. Similar to earlier requests, Malloy said he did not have the authority or feel it was right to censure another government, in another time—something state historian Walter Woodward believes is right. "It's hard to live in one time period, which has its own cultural mores, its own sense of right and wrong, and make effective judgments about another time period," Woodward said in a 2012 Religion News Service article that appeared on the Huffington Post website.

From today's perspective, Connecticut's witchcraft trials were an obvious injustice. But as discussed in Chapter 7, past events can't be interpreted through contemporary attitudes. "Once you start crossing the border," Woodward added, "you forget that the past is a foreign country. It's a slippery slope."

Connecticut Witch Hysteria

1636: English Puritans come to New England for religious freedom, settling the Connecticut Colony. They bring with them a staunch faith in God and laws created through a strict and literal translation of the King James Bible, which in Deuteronomy states: "There shall not be found among you [one who]…useth divination…[or is] an enchanter or a witch." Exodus admonishes, "Thou shalt not suffer a witch to live."

1642: Connecticut Colony lawmakers release a list of "Capitall Lawes" and crimes punishable by death. Practicing witchcraft is number two.

1647: Magistrates find Alse Youngs of Windsor guilty of witchcraft and hang her at the gallows at Meeting House Square in Hartford, now the location of the Old State House. Alse's death as a witch is the first to occur in Connecticut, New England and the New World, and it marks the start of Connecticut's witch hysteria.

1651: The first of several couples to be accused of witchcraft, John and Joan Carrington of Wethersfield, are convicted and hanged.

1655: John Winthrop Jr., a respected physician and alchemist, becomes a consultant to the magistrates deciding the trials.

1657–76: Winthrop is Connecticut's governor and chief magistrate. He believes in witchcraft but also that people are too quick to attribute "natural misfortunes" to Satan or the occult.

1662–63: While Winthrop is away in England obtaining the official royal charter from King Charles II that establishes Connecticut as an independent colony, the colony's witch panic reaches its peak. There are eight trials in eight months. Four accused witches are hanged, and at least five run away in fear of execution.

1662: The Royal Charter of the Connecticut Colony takes effect, granting Winthrop the right, as governor, to "impose, alter, change or annul any penalty" and to "pardon any of fender [sic]." He uses this new power to overturn the witchcraft conviction of Elizabeth Seager of Hartford, and for the first time in Connecticut, a convicted witch does not hang. His actions encourage other magistrates to not be so aggressive with witchcraft convictions and to adopt a policy of judicial skepticism. Many residents, however, are enraged and outspoken against this moderate stance.

1663–88: Witch hysteria fades; twenty-five years pass without a single witchcraft execution.

1668: Massachusetts' execution of confessed witch Mary Glover reignites fear about Satan's influence and the threat of witchcraft in the Connecticut Colony.

1669: Winthrop leads efforts to define "diabolical magic." At his request, fellow physician and alchemist Gershom Bulkeley heads a committee charged with reforming evidence needed for a witchcraft conviction. Changes include that two witnesses must simultaneously observe the act of witchcraft, following the belief that while God might allow Satan to appear in the guise of an innocent person before one witness, he would not allow it to occur before two or more. The new standards also acknowledged that predictions about future events made through "human skill in Arts" and reason were different from those made through diabolical divination.

1692: A second period of witch hysteria strikes Connecticut, leading to accusations in Fairfield, Stratford and Wallingford, among other locations.

What becomes known as the "Fairfield Witch Panic" coincides with that of Salem, Massachusetts.

1692: The only mother and daughter in Connecticut to be accused, Winifred and Winifred Benham of Wallingford, are said to be "afflicting people by witchcraft" but are released on insufficient evidence. Theirs is the last witchcraft trial to ever take place in Connecticut.

1724: Last recorded witchcraft charge on state records is made against Sarah Spencer of Colchester. Magistrates reject the claim; accuser Elizabeth Ackley pleads insanity and is fined by the court.

1750: The Connecticut General Assembly releases an updated list of capital offenses, and witchcraft is no longer on the list.

2008: A resolution to pardon those convicted and executed as witches in the 1600s is introduced in the General Assembly but doesn't make it out of committee.

2012: Members of the Connecticut Wiccan and Pagan Network ask governor Daniel Malloy to sign a nonbinding proclamation acknowledging colonial lawmakers wrongly accused and put to death innocent people during Connecticut's witch trials. Malloy says it's not appropriate for him to condemn previous government leaders' decisions.

Connecticut Residents Accused of Witchcraft, 1647–1724

Note: The towns of East Hampton and Setauket, now part of Long Island, New York, were originally part of the Connecticut Colony.

DATE	PERSON	RESIDENCE	RESULT
1647	Alse Youngs	Windsor	Hanged
1648 (again in 1672)	Katherine Palmer	Wethersfield	Released with warning
1648	Mary Johnson	Wethersfield	Hanged
1651	Joan and John Carrington	Wethersfield	Hanged
1651	Goody Basset	Stratford	Hanged
1653	Goody Knapp	Fairfield	Hanged
1654 (again in 1692)	Mary Staples	Fairfield	Exonerated and awarded damages for slander
1654	Lydia Gilbert	Windsor	Hanged
1655	Elizabeth Godman	New Haven	Released with warning
1655	Nicholas Bailey and wife	New Haven	Acquitted and ordered to leave Connecticut

DATE	PERSON	RESIDENCE	RESULT
1657	William Meeker	New Haven	Exonerated and awarded damages for slander
1658	Elizabeth Garlick	East Hampton	Acquitted
1661	Margaret and Nicholas Jennings	Saybrook	Released with warning
1662	Judith Varlet	Hartford	Believed to be released with warning
1662	Goody Ayers	Hartford	Fled Connecticut with her husband, who also appears to have been accused
1662	Mary and Andrew Sanford	Hartford	Mary hanged, and Andrew released with a warning
1662	Rebecca and Nathaniel Greensmith	Hartford	Hanged
1662	Mary Barnes	Farmington	Hanged
1662	Elizabeth and John Blackleach	Wethersfield	Complaint filed but apparently not pursued
1663	James Wakeley	Hartford	Fled Connecticut
1663 (twice accused this year and again in 1665)	Elizabeth Seager	Hartford	Acquitted of witchcraft at both 1663 trials, but at second convicted of adultery
1663	Judith Varlett	Hartford	Released to her brother in New York
1664	Mary and Ralph Hall	Setauket	Acquitted
1665	Elizabeth Seager (third time)	Hartford	Convicted, but governor overturns verdict; she moves to Rhode Island
1665	John Brown	New Haven	Released with warning

DATE	PERSON	RESIDENCE	RESULT
1665	Hannah Griswold	Saybrook	Exonerated and awarded damages for slander
1665	William Graves	Stamford	Complaint filed but not prosecuted
1667	Katherine Palmer (second time)	Wethersfield	Fled to Rhode Island
1669	Katherine Harrison	Wethersfield	Hung jury; moved to New York
1669	Sarah Dibble	Stamford	Accused by her husband; no action
1673	Goody Messenger	Windsor	Exonerated and awarded damages for slander
1678	Mary Burr	Wethersfield	Exonerated and awarded damages for slander
1689	Goody Bowden	New Haven	Exonerated and awarded damages for slander
1692	Mercy Disborough	Fairfield	Convicted, but given reprieve on a technicality
1692	Mary Staples (second time)	Fairfield	Conflicting records on whether was prosecuted
1692	Mary Harvey	Fairfield	Conflicting records on whether was prosecuted
1692	Elizabeth Clawson	Stamford	Acquitted
1692	Hannah Harvey	Fairfield	Conflicting records on whether was prosecuted
1692	Goody Miller	Fairfield	Fled to New York
1692	Winifred and Winifred Benham (mother and daughter)	Wallingford	Released on insufficient evidence

DATE	PERSON	RESIDENCE	RESULT
1692	Hugh Crotia	Fairfield	Magistrates refused to indict
1713	Sarah Clother	Colchester	No action
1713	Goody Brown	Colchester	No action
1724	Sarah Spencer	Colchester	Court rejects and fines accuser

Bibliography

Used throughout this book are excerpts from surviving 1600s Connecticut witch trial documents included in the Samuel Wyllys Papers—collections from the former Hartford Generall Court magistrate that are housed in archives at two locations: the Connecticut State Library and Brown University's John Hay Library in Providence, Rhode Island. Images of many of these documents can be viewed online as part of each institution's digital resources. Other sources include:

Bendici, Ray. "Goodwife Bassett," Damned Connecticut. http://www. damnedct.com/goodwife-bassett.

Black, Robert. *The Younger John Winthrop*. New York: Columbia University Press, 2nd ed., 1968.

Burr, George Lincoln, ed. *Original Narratives of Early American History: Narratives of the Witchcraft Cases, 1648–1706*. New York: Charles Scribner's Sons, 1914.

Campbell, Susan. "The Effort to Exonerate Those Executed for Witchcraft in Connecticut Continues." *Connecticut Magazine*, August 2013.

"The Case of Lydia Gilbert." *New-England Galaxy* 5 (Winter 1964): 14–23.

Church of England. *King James Bible*. London: Robert Barker, "printer to the King's most Excell[e]nt Maiestie," 1611.

Dalton, Michael. *The Country Justice*. London: printed by W. Rawlins and S. Roycroft, 1690. Viewed at Maryland State Archive.

Demos, John P. *Entertaining Satan: Witchcraft and the Culture of Early New England*. New York: Oxford University Press, 1983.

Dewan, George. "Goody Garlick: Witch-hunting Was Not Limited to Salem, Massachusetts, in the Nascent America of the Seventeenth Century." *New York Archives*, Fall 2005: 7–9.

Fuller, Carol Seager. *An Incident at Hartford: Being an Account of the Witchcraft Trials of Elizabeth Seager and Others*. Brevard, NC: Cordelia T. Seager and Charles W. Seager, 1979.

Gillespie, C. Bancroft, ed. *An Historical Record and Pictorial Description of the Town of Meriden, Connecticut, and the Men Who Made It*. Meriden, CT: Journal Publishing Co., 1906.

Godbeer, Richard. *Escaping Salem: The Other Witch Hunt of 1692*. New York: Oxford University Press, 2005.

Gordon, Maggie. "Haunted Stamford: 1692 Witch Trial." *Stamford Advocate*, October 30, 2013.

Grant, Ellsworth. "Connecticut's Witch Hunt." *Northeast Magazine, Hartford Courant*, October 28, 1984: 12–19.

Hall, David D. "Witchcraft and the Limits of Interpretation," *New England Quarterly* 58, June 1985: 253–81.

———, ed. *Witch-Hunting in Seventeenth-Century New England: A Documentary History 1638–1693*. 2nd ed. Durham, NH: Duke University Press Books, 2005.

Harris, Gale Ion. "Henry and Katherine Palmer of Wethersfield, Connecticut and Newport, Rhode Island." *The Genealogist* 17 (Fall 2003): 175–85.

Hartford Evening Post. "Witches of Windsor." July 29, 1885.

Hedges, Henry Parsons. *Records of the Town of East Hampton, Long Island, Suffolk Co., N.Y.: With Other Ancient Documents of Historic Value*. Vol. 1. East Hampton, NY: J.H. Hunt, 1887.

Hoadly, Charles J. "A Case of Witchcraft in Hartford." *Connecticut Magazine* 5, no. 10 (October 1899): 557–61.

———, ed. *The Public Records of the Colony of Connecticut, from August, 1689, to May, 1706*. Hartford, CT: Press of Case, Lockwood and Brainard, 1868.

Hopkins, Matthew. *The Discovery of Witches*. 1647. http://www.gutenberg.org/ebooks/14015.

Hornstein, Harold O. "'Witches' or 'Uppity Women?'" *New Haven Register*, October 29, 1972.

Jacobus, Donald Line. *Families of Ancient New Haven*. Reprint, Baltimore: Genealogical Publishing Company, 1974.

———. *The History and Genealogy of the Families of Old Fairfield*. Reprint, Baltimore, MD: Clearfield Company by Genealogical Publishing Company, 2007.

Jarman, Rufus. "Our Own Witches." *Fairfield County Magazine*, October 4 1974: 50–57.

Karlsen, Carol F. *The Devil in the Shape of a Woman: Witchcraft in Colonial New England*. New York: Norton, 1987.

Kurz, Jeffery. "The Wallingford Witch Project." *Record-Journal of Meriden-Wallingford-Southington-Cheshire*, December 31, 1999.

Langdon, Carolyn S. "A Complaint Against Katherine Harrison, 1669." *Bulletin of the Connecticut Historical Society* 34, no. 1 (January 1969): 18–25.

Leslie, Frank. *Popular Monthly* 10 (July to December 1881). New York: Frank Leslie's Publishing House. http://books.google.com/books?id=nodVAA AAYAAJ&pg=PA304&lpg=PA304&dq=juliana+cox+glastonbury&sour ce=bl&ots=qiwELsNeQG&sig=9gZlUWA41JkYlWEOBeKkAbfa8NA& hl=en&sa=X&ei=Ph_VU9bpGoHisATnvYGgBw&ved=0CB0Q6AEw AA#v=onepage&q=juliana%20cox%20glastonbury&f=false.

Linder, Douglas O. "Famous American Trials: Salem Witchcraft Trials, 1692. Biographies: Cotton Mather." http://law2.umkc.edu/faculty/ projects/ftrials/salem/SALEM.HTM.

"Mary Parsons of Springfield." *Remarkable Women of the Pioneer Valley*. Pioneer Valley History Network. http://pvhn2.wordpress.com/1600-2/mary-parsons-of-springfield/.

Mather, Cotton. *Memorable Providences, 1689 and Magnalia Christi Americana (The Glorious Works of Christ in America)*, 1702. http://law2.umkc.edu/faculty/ projects/ftrials/salem/asa_math.htm.

Middlekauff, Robert. *History of Education Quarterly* 8, no. 2 (Summer 1968): 253–55.

New Haven Register. "The 'Witch' Who Was Spared from New Haven's Gallows." October 29, 1962.

Norman-Eady, Sandra, and Jennifer Bernier. "Connecticut Witch Trials and Posthumous Pardons." Connecticut Office of Legislative Research. http://www.cga.ct.gov/2006/rpt/2006-R-0718.htm.

Pagliuco, Chris. "Connecticut's Witch Trials." *Hog River Journal*, Winter 2007/08.

Reis, Elizabeth. "Confess or Deny? What's a 'Witch' to Do?" *Organization of American Historians Magazine of History*, July 2003: 11–15.

———. *Damned Women: Sinners and Witches in Puritan New England*. Ithaca, NY: Cornell University Press, 1997.

Roach, Marilynne J. "9 Reasons You Might Have Been Suspected of Witchcraft in 1692." Huffington Post. http://www.huffingtonpost.com/ marilynne-k-roach/9-reasons-you-might-have-_b_4029745.html.

Shelton, Alice. "Witches of Westport: There's a History Here." WestportNow. com, 2003. http://www.westportnow.com/index.php?/v2/comments/ witches_of_westport_theres_a_history_here/.

Somma, Ann Marie, for Religion News Service. "Connecticut Witch Trial Descendents Want Justice," Huffington Post. http://www. huffingtonpost.com/2012/10/01/connecticut-witches-descendants-want-justice_n_1930455.html.

Spencer-Molloy, Frank. "Medical Science Casts New Light on 1661 Tale of Witchcraft." *Hartford Courant*, October 31, 1993.

Squires, Stephen Taylor. *Are There Witches? Being a True Tale of Discovering a Connecticut Ancestor Accused of Witchcraft.* N.p.: self-published, n.d. Accessed from Connecticut State Library's Connecticut witchcraft files.

Taylor, John M. *The Witchcraft Delusion in Colonial Connecticut.* New York: Grafton Press, 1908.

Tomlinson, R.G. *Witchcraft Prosecution: Chasing the Devil in Connecticut.* Rockland, CT: Picton Press, 2012.

Trumbull, J. Hammond ed. *Public Records of the Colony of Connecticut Prior to the Union with New Haven Colony, May 1665.* Vol. 1. Hartford, CT: Brown & Parsons, 1850.

Weir, William. "A Descendant's Duty." *Hartford Courant*, October 22, 2006.

Whipps, Heather. "Urban Legends: How They Start and Why They Persist." LiveScience.com, 2006.

"Witchcraft." *New Encyclopaedia Britannica.* Vol. 25, macropaedia, Chicago: 15th edition.

Womack, Jeffrey. "Human Diseases and the Environment." *Encyclopedia of American Environmental History.* New York: Facts On File, 2010.

Woodward, Walter W. *Prospero's America: John Winthrop, Jr., Alchemy, and the Creation of New England Culture, 1606–1676.* Chapel Hill: University of North Carolina Press, 2010.

Index

A

Allyn, Thomas 59, 61
Ayers, Judith 43, 44, 45, 48, 49, 52, 116

B

Backleach, John and Elizabeth **49**
Bailey, Nicholas 115
Barnes, Mary 13, 49, 50, 116
Basset, Goody 11, 12, 41, 43, 115
Benham, Joseph 92, 94
Benham, Winifred 90, 91, 96, 113, 117
Bowden, Goody 117
Branch, Catherine 52, 53
Brown, Goody 118
Brown, John 116
Brown, Thomas 96
Bulkeley, Gershom Reverend 57, 76,
 78, 87, 90, 112
Burr, Mary 117

C

Carrington, Joan and John 41, 43, 61,
 107, 111, 115
Churchill, Sir Winston 104
Clawson, Elizabeth 52, 55, 117

Clother, Sarah 96, 118
Cox, Julia 98, 99, 100
Crotia, Hugh 12, 118

D

Dibble, Sarah 117
Disborough, Mercy 52, 55, 58, 87, 89

F

Fuller, Carol Seager 23

G

Garlick, Elizabeth 27, 29, 116, 120
Gilbert, Lydia 59, 60, 104, 115, 119
Glover, Mary 112
Godman, Elizabeth 62
Graves, William 117
Greensmith, Nathaniel 45, 49, 68
Greensmith, Rebecca 41, 68, 74, 106
Griswold, Hannah 117

H

Harrison, Katherine 73, 75, 78, 79, 80,
 87, 117, 121

Harvey, Hannah 117
Harvey, Mary 117

J

Jennings, Nicholas and Margaret 68, 116
Johnson, Mary 7, 34, 37, 38, 41, 43,
 89, 102, 115

K

Kelly, Elizabeth 43, 44, 47, 48, 52
Knapp, Goody 41, 43, 65, 67, 115

L

Ludlow, Roger 67, 87

M

Malloy, Governor Dannel P. 109
Mather, Cotton 17, 23, 34, 89, 121
Mather, Increase 48, 83
Meeker, William 64
Messenger, Goody 117
Miller, Goody 117

N

New York Times 126

P

Palmer, Katherine 35, 41, 43, 115,
 117, 120
Parsons, Hugh and Mary 61

R

Rossiter, Bryan 47, 49, 88

S

Sanford, Andrew 49, 116
Seager, Elizabeth 23, 41, 47, 49, 50,
 76, 77, 80, 112, 116, 120
Speare, Elizabeth George 13, 102
Spencer, Sarah 96, 113, 118
Stanford, Mary 106
Staples, Mary 65, 67, 87, 104, 115, 117

Stiles, Henry 59, 60
Stone, Reverend Samuel 35, 89

V

Varlet, Judith 49, 116

W

Wakeley, James 49, 116
Webster, Noah 104
Whiting, Reverend William 36, 38
Winthrop, Governor John, Jr. 19, 33,
 42, 44, 47, 50, 71, 72, 73, 76,
 77, 78, 85, 87, 89, 90, 111, 112,
 119, 122
Winthrop, John, Sr. 19, 33, 42
Wyllys, Samuel 12, 85, 89, 119

Y

Youngs, Alse 19, 20, 31, 33, 41, 43,
 111, 115

About the Author

In 1996, a week or so after writing a story for the *Boston Globe* about New England Wiccans' reactions to the trial of a Connecticut school bus driver accused of casting spells to seduce a fourteen-year-old student, author Cynthia Wolfe Boynton received a letter in a thick, creamy envelope held shut with a round, red wax seal. Ribbons and herbs fell out with the letter. "Your story helped dispel many myths about wiccans," said the anonymous writer in swishy, quill-dipped blue ink. "Thank you. Blessed be."

Not sure exactly what a Wiccan was, Cindy's husband, Ted, paled a bit at the letter. Cindy, however, thought it was wonderful and since then has focused much of her work on helping people better understand one another. She started by telling Ted the difference between being a witch and a Wiccan, which in essence boils down to this: a witch in the traditional sense is someone who uses incantations, spells and supernatural magical to influence people and events, while a Wiccan is someone who practices Wicca, a nature-based religion that celebrates the seasons and performs nature-based magic as part of rituals. Witchcraft is a form of sorcery,

while Wicca is a form of spirituality. Not all Wiccans practice witchcraft, and not all witches are Wiccans.

An award-winning journalist, playwright and poet, Cindy is a freelance writer whose background includes more than fifteen years as a regular correspondent for the *New York Times* and nine years as editor and publishing director of *Better Health* magazine. Her two most recent plays, *Right Time to Say I Love You* and *Dear Prudence*, both made their premieres in New York City, just steps off Broadway, at the 2011 and 2013 United Solo Theatre Festival, and were recognized for being top scripts. *Right Time* continued with performances that took her to Brighton, England, and one of the largest theater festivals in the world.

A Connecticut resident, Cindy is also an English and communications instructor at the Yale School of Medicine and Housatonic Community College, as well as host of the weekly *Literary New England Radio Show* podcast. Her proudest accomplishments, however, are her sons, Teddy and Steven.

Fascinated by history and drawn to telling stories that connect the past and present, Cindy has written two books for The History Press, this one and *Remarkable Women of Hartford*, published in March 2014. Learn more about her and work by visiting www.cindywolfeboynton.com.